IMAGES
of America

GUADALUPE

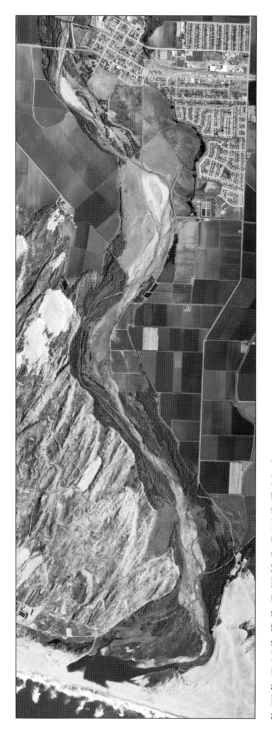

While statistics surrounding the Santa Maria River change according to annual rainfall, it flows approximately 24.4 miles to its delta at the Pacific Ocean in the Guadalupe-Nipomo Dunes. The river begins at the confluence of the Sisquoc and Cuyama Rivers and follows the line separating San Luis Obispo and Santa Barbara Counties. The Santa Maria River also reportedly follows the path of a tectonic fault. The river has brought eons of silt from the nearby mountains, creating the fertile Santa Maria Valley and depositing the sand that now lays on the beaches between Pismo Beach in the north and Point Sal in the south. Today, the river only flows after winter storms, due to the Twitchell Dam, which provides water conservation and flood control. (Dunes Center files.)

ON THE COVER: The Souza & Grisingher Store is pictured around 1907. Antone Souza and Peter Grisingher opened the store and later expanded to a larger facility nearby. The building still stands along the main thoroughfare through town, which is aptly named Guadalupe Street. The road also serves as California's Highway 1. (Family of Nadine Grisingher Ferini and Dario Ferini.)

IMAGES
of America

GUADALUPE

Doug Jenzen
Guadalupe-Nipomo Dunes Center

ARCADIA
PUBLISHING

Published by Arcadia Publishing
Charleston, South Carolina

Printed in the United States of America

Library of Congress Control Number: 2013944968

For all general information, please contact Arcadia Publishing:
Telephone 843-853-2070
Fax 843-853-0044
E-mail sales@arcadiapublishing.com
For customer service and orders:
Toll-Free 1-888-313-2665

Visit us on the Internet at www.arcadiapublishing.com

*To the Talaugon family, who have helped celebrate, promote,
and preserve our unique local heritage for future generations.
"No history, no self. Know history, know self."*

CONTENTS

ACKNOWLEDGMENTS

When beginning this project in late 2012, I was torn between compiling a book on either the City of Guadalupe or the Guadalupe-Nipomo Dunes Complex. It was a difficult decision, because both Guadalupe and the Dunes have stories and a heritage that deserve to be told. However, once I began working on this project, I realized that the two locations are inseparable. When I asked locals to share their old family photographs with me, inevitably, everyone had historical photographs of both Guadalupe and the Guadalupe-Nipomo Dunes, demonstrating that the Dunes were an integral part of the lives of Guadalupe's residents, providing people with a place to spend their free time.

There are many people to whom I would like to express my gratitude for helping complete this project, including Darlene Krouse; Shirley Boydstun and the supportive members of the Rancho de Guadalupe Historical Society; Erin Wighton at the History Center of San Luis Obispo County; my travel companion, Hannah Sidaris-Green; Paula Carr at Caltrans; Susan Duran, who helped get this project started on the right track; Leslie Mosson and Colleen Beck from the Allan Hancock College Library, who made researching the project a little easier; Dawn Kurakawa Kamiya, who appeared as an advocate when I needed one; Peter Brosnan, who laid the groundwork for some of the research contained in this book; Ernie De Gasparis; Belen Enriquez; the Maenaga family; the Soares family; and Leigh Moulder, who has now passive-aggressively survived two books, a master's thesis, and a teaching credential.

Finally, I would like to thank the Guadalupe-Nipomo Dunes Center board of directors, staff, volunteers, and supporters, who helped make this project possible, which we hope will celebrate the City of Guadalupe and the Guadalupe-Nipomo Dunes. Their generous financial and service-oriented donations were vital.

All of the author's royalties from the sales of this book are being donated to the Guadalupe-Nipomo Dunes Center.

The Guadalupe-Nipomo Dunes Center is a 501(c)(3) nonprofit natural history museum that serves thousands of schoolchildren, local residents, and tourists each year through quality educational programming. The organization's mission is to promote the conservation and restoration of the Guadalupe-Nipomo Dunes ecosystem through education, research, and the support of cooperative stewardship.

Introduction

The region's history is intertwined with the story of the Santa Maria River. For eons, the river has carried silt from the local hills and mountains, depositing the material along its riverbed and into the ocean. The silt left behind on the river's course to the ocean created the fertile land of the Santa Maria Valley that reached to the Pacific. Ocean movement over the millennia ground pebbles and stones near the shore into the fine sand that created the Guadalupe-Nipomo Dunes Complex, which stretches from what today is referred to as Pismo Beach in the north, to Point Sal in the south.

Several thousand years of natural and human history created geographic features that allowed people to survive and create the world as we know it today. The Nipomo Mesa is a massive sand dune that began forming along the coast approximately 15,000 years ago. More recently formed sand dunes that look familiar to the casual passerby trapped fresh water in certain areas, allowing the formation of unique ecosystems containing plants and animals. The first people arrived in the region approximately 10,000 years ago. They used these natural resources to survive, and their descendants have inhabited the region ever since.

The cultures of two continents collided in 1769. Gaspar de Portola and his crew made their way through the Guadalupe region. One crewmember estimated that there were 10 Native American settlements in the area. The crew killed and consumed a skinny bear while staying in the area, and this lent the name to a body of water, Oso Flaco (thin bear) Lake. In 1787, Spanish Franciscans established the nearby Mission La Purisima de la Conception, which changed the lives of locals forever. Mission holdings incorporated the Native American population of Chumash as laborers; the Spanish converted them into Catholics, and taught them the ways of the European lifestyle. The Spaniards initiated agriculture as it is known today, but they decimated the local indigenous population in the process.

Turmoil followed Mexican independence in 1821. Mexico secularized mission holdings, which allowed for individuals (typically wealthy Americans, Europeans, or Mexican elite) to acquire vast amounts of land from the Mexican government. In 1840, California governor Juan Alvarado deeded 43,682 acres to two men, Diego Olivera and Teodoro Arrellanes. The large landholding was called Rancho de Guadalupe, after the Virgin of Guadalupe, the patron saint of Mexico. The two men raised tens of thousands of cattle and employed the Chumash workers displaced during mission secularization. Rancho de Guadalupe contained a large portion of coastal Santa Maria Valley and the dunes complex. However, their neighbor to the north also received coastal dune property.

The US annexation of the West Coast from Mexico following the Mexican-American War in the 1840s caused legal complications among Mexican landowners. Everyone who had received a land grant from Mexico had to proceed through a complicated and costly battle to prove ownership to the US government. This process was further complicated on Rancho de Guadalupe, where the Mexican government deeded the land to two men whose heirs sued each other over property

ownership. The grant was confirmed in the US District Court in 1857, but was actually issued to Olivera and Arrellanes in 1870. By that point, however, the property had changed hands.

Rancho de Guadalupe's new owners subdivided the vast tract of land. John Ward, who married into the original landholding family, began operating a ranch and built a second adobe on the property in 1867. Theodore and Victor Le Roy, two wealthy French bankers who made their fortunes during the California Gold Rush, acquired the rancho for $42,000 in 1870. The Le Roys subdivided Rancho de Guadalupe and sold parcels to many Swiss-Italian and Portuguese immigrant farmers, who operated dairy farms in the Guadalupe and Oso Flaco Lake region. The farmers shipped their goods by boat to distant markets by utilizing a nine-mile stretch of road that John Ward built to Point Sal while operating a mine in the area.

By the late 1870s, Guadalupe was becoming a full-fledged town, due to the region's agricultural success. Booming agriculture required laborers, who arrived from around the world. Waves of Chinese, Japanese, Filipino, and American workers have fueled the industry ever since.

The Southern Pacific Railroad arrived in Guadalupe in 1895. The railroad allowed for the rapid transportation of goods and people to the north. By 1901, the line between San Francisco and Los Angeles was complete, creating a boomtown out of any community fortunate enough to have a station along the Southern Pacific, including Guadalupe. The legacy of the period of prosperity can be seen in the architectural styles of many structures around the city today.

The Guadalupe-Nipomo Dunes have played a major role in the region. Everyone who has ever lived in the region has utilized the dunes in some way. Many capitalize on the creeks and ocean in the dunes complex for their natural bounty. Others have utilized the dunes for recreational purposes. As long as there have been cars, people have driven on the beach. These motorists did not always enjoy a smooth ride, as cars often got stuck in the dune sand.

In the early 20th century, Hollywood discovered Guadalupe and the nearby Guadalupe-Nipomo Dunes. *The Sheik* was the first film produced by the Famous Players–Lasky Corporation. The Dunes were used as the backdrop. Famous Players–Lasky may have set a precedent, as Cecil B. DeMille used the Dunes to serve as ancient Egypt in his 1923 version of *The Ten Commandments*. More recently, *GI Jane*, *The Odd Couple II*, and *Pirates of the Caribbean: At World's End* featured Guadalupe and/or the Guadalupe-Nipomo Dunes as a backdrop.

Life was not always easy in Guadalupe. Occasional floods devastated the city, and economic disasters took a toll. Famed photographer Dorothea Lange visited the area during the 1930s and captured the rough working conditions of agricultural workers. Later, she captured Guadalupe residents again, photographing the conditions in Japanese internment camps.

The past has left a legacy in Guadalupe and the neighboring Guadalupe-Nipomo Dunes Complex. Agriculture and tourism are the forces behind the region's economy. Locals and tourists alike still visit the Dunes, while the past can be seen in the ethnically diverse faces of the city's population and the many cultural traditions still maintained in the region.

One

THE EARLY YEARS

The availability of natural resources and the ability to transport them have played a major role in the development of the Central Coast. From the settlement of the first people to the present day, the local natural bounty has allowed people to prosper, although sometimes not so easily.

The region's recent history begins with the convergence of Spanish and American culture. The indigenous Chumash group occupied the area for thousands of years when Spaniards arrived in the 1700s. One aspect that both cultures shared is that the ocean and its bounty provided for their survival. Early Americans used the Pacific for sustenance; Europeans used the ocean for its economic benefits.

After Mexico gained independence from Spain in the 1820s, the government opened up the region to entrepreneurs. Americans and Europeans moved to the area to participate in the otter fur trade. However, once the otter population diminished, these settlers turned to the hide and tallow trade, taking up vast land tracts granted to them by the Mexican government. Men like Teodoro de Arellanes and Diego Olivera of Rancho de Guadalupe raised tens of thousands of cattle for their hides. This material, shipped to the United States, fueled the nation's industrial revolution. Drought in the 1860s, along with economic factors, caused a major upheaval among local landowners. Rancho de Guadalupe changed hands four to five times in a matter of 13 years, due to the weather making it difficult for farmers to succeed and the land speculation that took place among investors.

During the 1870s, local agricultural production depended upon ships for transportation to distant markets. Investors built wharves up and down California's coast, including Point Sal near Guadalupe. A six-horse team took three days to travel from Guadalupe to the wharf.

Local mining companies also required ships to transport their goods. Miners removed gold and gypsum from the earth and shipped it to cities such as San Francisco for processing.

The availability of local resources from agriculture and mining, combined with the availability of transportation via ship, allowed Guadalupe and the surrounding area to prosper economically. This success attracted a large and diverse population from around the world.

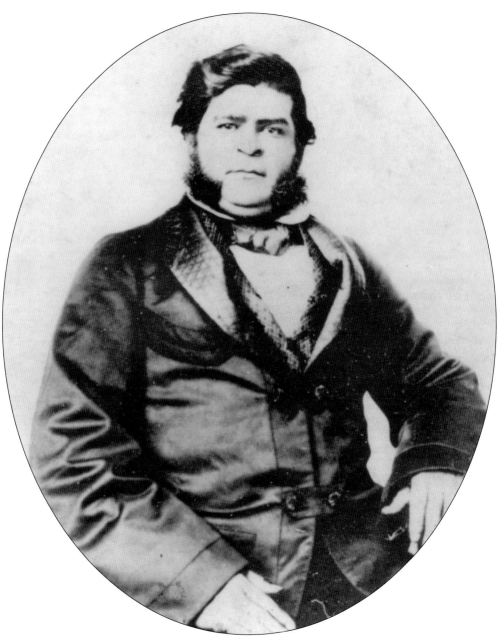

One of the recipients of the Rancho de Guadalupe land grant from the Mexican government, Teodoro de Arellanes, was born in 1782. Arellanes's origin is disputed. Some sources state that he was born in Alamos, Sonora, in Mexico, while others report that he was born in Santa Clara in Alta California. The "de" in his name implies that he is descended from the Spanish elite. Arellanes served as superintendent of La Purisima Mission when he took note of the Santa Maria Valley. By 1852, he lived with his daughters and employed three Native American *vaqueros*, Juan, Tomas, and Matteo. His business partner, Diego Olivera, who managed the rancho with Arellanes, has disputed origins as well. He was born in Chile, according to the 1850 census, which lists "clerk" as his occupation. The 1860 census, however, lists his place of birth as California and his occupation as "stock raiser." (Rancho de Guadalupe Historical Society.)

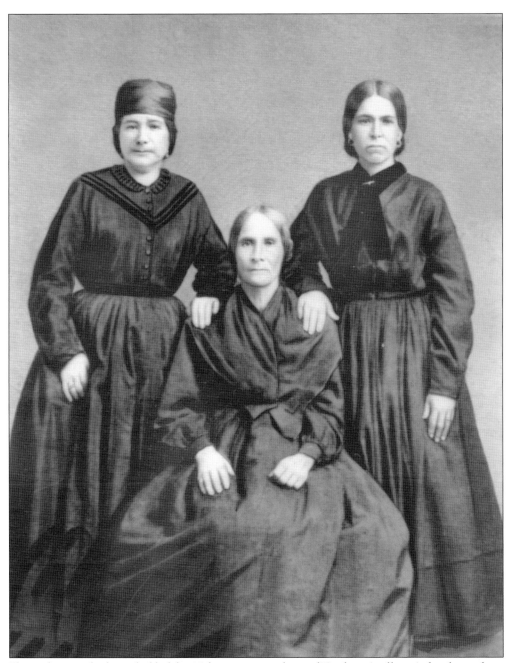

Shown here in the latter half of the 19th century are three of Teodoro Arellanes's daughters, from left to right, Maria de los Reyes Arellanes, Maria Ignacia, and Maria Jesus Rita Arellanes. The descendents of the Arellanes family participated in the difficult land-dispute process as part of American annexation of California after the Mexican-American War. (Rancho de Guadalupe Historical Society.)

In 1843, Olivera and Arrellanes built a one-story adobe structure. John Ward built the second adobe structure in 1867, consisting of two stories. Some believe it to be the first building in California with a redwood shingled roof. Both homes provide a unique look into California's multicultural past through the blending of American and Mexican architectural styling and construction, often referred to as Monterey Colonial, because the New England–style buildings were constructed using local materials and labor. During the 1930s, surveyors with the Historic American Building Survey, which the Roosevelt administration created as part of the New Deal to put architects and engineers back to work, visited Guadalupe and surveyed the adobe structures, leaving records for future generations. Their documents include measurements, blueprints, and detailed architectural features. The buildings themselves are gone. (Library of Congress.)

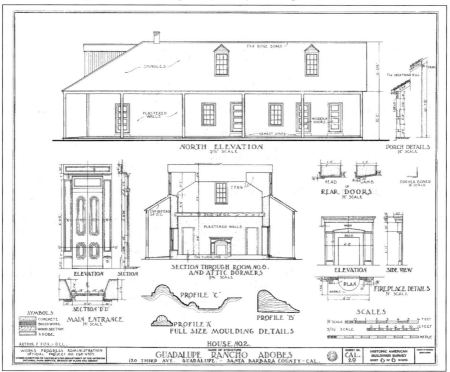

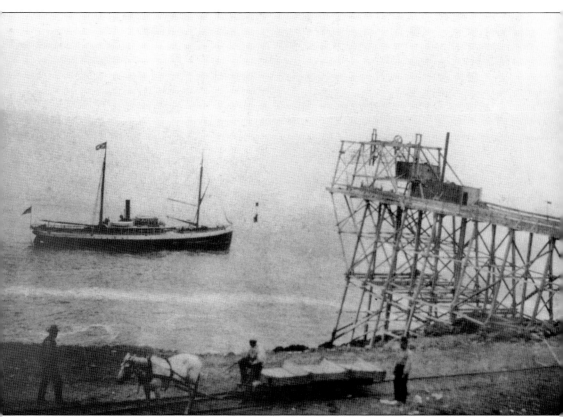

Local businessmen invested in the construction of Chute Landing to compete with the nearby Point Sal wharf, operated by Charles Haskell Clark. Farmers complained about the high price of shipping from Point Sal, so J.H. Rice, Paul Bradley, A.J. Triplet, S.D. Triplet, J.K. Triplet, Charles Bradley, H. Stowell, A. Leslie, and W.L. Adam invested in Chute Landing, the scheme of French Canadian Ono St. Ores. Ships at the Landing were loaded and unloaded using a cable-and-pulley system. The first delivery of grain arrived at Chute Landing on July 21, 1880. Now, local farmers could ship their goods to distant markets; Santa Maria Valley agriculturists were connected to the rest of the world. Chute Landing was part of an overall trend of wharf-building that took place along California's coast in the latter half of the 1800s. (Susan Duran.)

Noe and Maria Gentila Tognazzini pose for this 19th-century photograph. The Tognazzini family immigrated to California from Switzerland by way of Australia. Born in Someo, Switzerland, in 1841, Noe immigrated to Australia in 1855, where he married Maria G. Zannoli. (Susan Duran.)

The white house located at Chute Landing belonged to the Tognazzini family, who settled at Point Sal. Noe worked in gypsum mines and took up a homestead on government property. Maria signed a lease with her half-brother and operated a dairy nearby. In 1908, Noe moved to Guadalupe. (Susan Duran.)

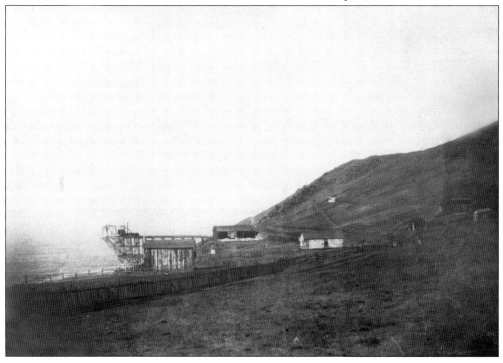

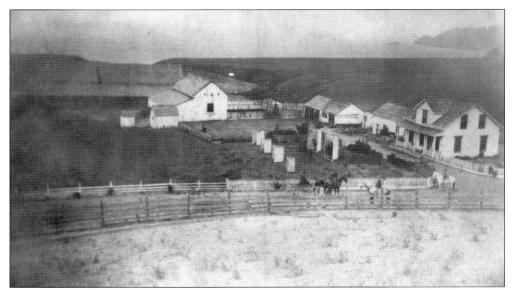

The white house seen in this photograph belonged to Charles Haskell Clark. He was born in Vermont and moved to California in 1857. Once he moved to Point Sal, he saw the need for a wharf to ship and receive goods. In 1874, Clark and his partner, W.D. Harriman, built a wharf to meet the needs of local businesspeople. Guadalupe businessperson John Ward built a nine-mile road to Point Sal through Rancho de Guadalupe, facilitating the movement of goods to the wharf. (Susan Duran.)

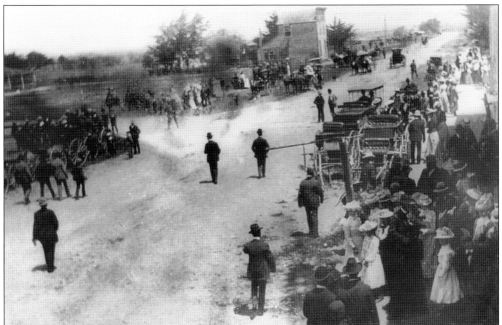

An unidentified event is taking place in the late 19th century in what is now downtown. The view is to the north on Guadalupe Street. The photograph was taken prior to the development of much of the city. Horses and carriages surround men walking down the street. The prominent building in the distance once stood at what is today 1045 Guadalupe Street. The Rancho de Guadalupe adobe structures are visible at far left. (Guadalupe Cultural Arts and Education Center.)

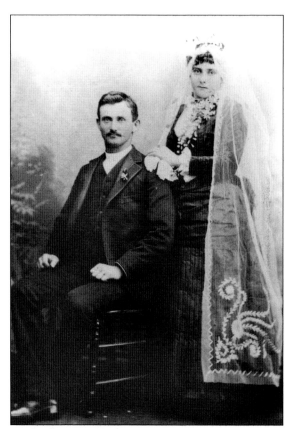

After emigrating from Switzerland in the 1870s, Antonio Bassi married San Luis Obispo native Augusta Scheifferly in 1886 (left). Bassi was part of a larger movement of immigration from Switzerland to California's Central Coast. Many Swiss immigrants helped establish the local dairy industry until they saved enough to begin their own farms. The below photograph, taken around 1895, shows the Bassis and their children, from left to right, William, Charles, Edward, and Virginia. (Family of Nadine Grisingher Ferini and Dario Ferini.)

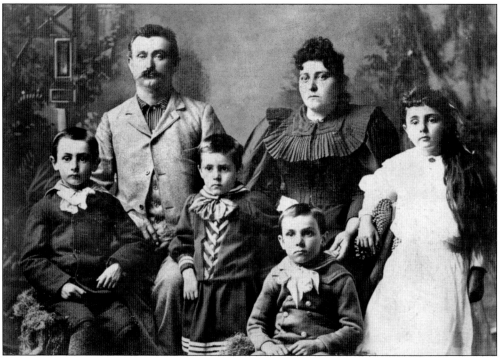

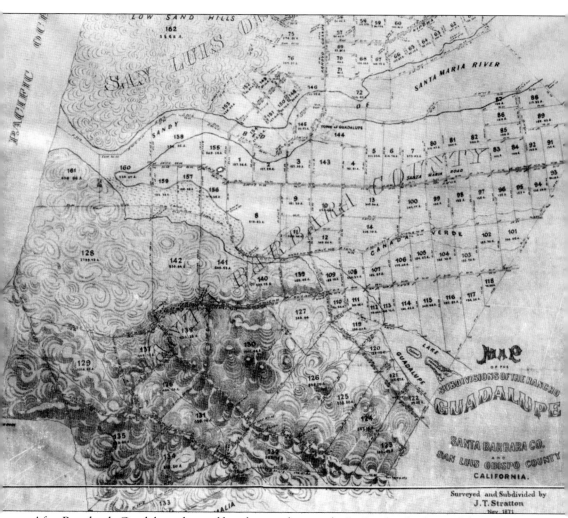

After Rancho de Guadalupe changed hands several times, the Le Roy family obtained the property and began subdividing it. A surveyor named J.T. Stratton created this map, entitled "Stratton Survey and Subdivision." It shows many of the first property lines established in Rancho de Guadalupe in 1871. (Rancho de Guadalupe Historical Society.)

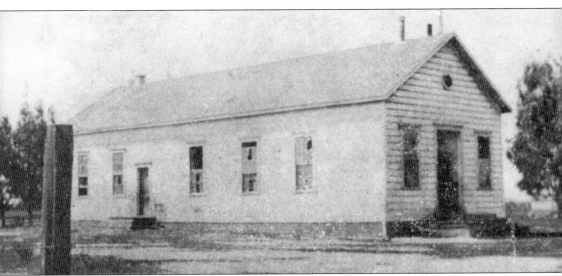

Guadalupe's growing population required more public amenities. The town's first school was established in 1873 and employed one teacher. The schoolhouse was abandoned in 1897, when the growing community required a larger school. (Rancho de Guadalupe Historical Society.)

Two

THE BOOM YEARS

Scandal rocked Guadalupe at the turn of the century. In 1901, a local newspaper ran a story entitled "Results of the Contest: Chinamen Win Prizes for the Best Sugar Beets." The sugar beet company in Betteravia sponsored a contest among local residents for the largest sugar beets. Of the six winners, five were Chinese immigrants. Commentary flooded the newspapers with speculation as to why this was the case. The decided-upon reason was, "not because of the superior agricultural ability of the Chinaman, but because they have paid higher rents than the white men." In reality, they paid higher rent because of their race, not the quality of their land.

This anecdote epitomizes some of the conflict that occurred with a population and industrial explosion resulting from the arrival of the Southern Pacific Railroad in 1894, more than likely thanks to Chinese labor. The rail line was extended to Santa Barbara four years later, connecting Guadalupe to Southern California.

What came to be known as the Coast Line followed the route originally established by Don Gaspar de Portola in 1769. In 1853, the US Congress passed the first of the Pacific Railroad Acts, which provided funding for explorations and surveys for railroad lines to the Pacific Ocean. By November 1854, Lt. John G. Parke led a party to trace a route from San Francisco to Los Angeles. This expedition, arriving in Guadalupe late that same year, established the railroad line that would subsequently encourage economic development and growth of the town.

Horticulture became king, in part due to the ability to transport goods and people rapidly over long distances. The fertile soils allowed farmers to grow an increasing variety of vegetables, much more than the grain commonly grown in the 1800s. Farmers began growing lettuce, beans, sugar beets, and even flower seeds for export around the world, thanks to an influx of new ideas from longstanding Americans and immigrants, and the advent of new technology.

Cultural diversity accompanied agricultural diversity as waves of immigrants arrived on the Central Coast and moved with the planting and harvest seasons. Chinese immigrants came to the area with the railroad and stayed to work in agriculture. Japanese and Filipino workers followed, as the increased demand caused a labor shortage. This in turn required farmers to hire labor contractors to recruit farm workers.

Regardless of origin, each group that arrived in Guadalupe brought its own perspectives that contributed to the formation of the prosperous region.

The Christmas of 1894 brought Guadalupe a wonderful gift. A crew laying railroad tracks along the Southern Pacific arrived in town on December 25 of that year. Advance graders moved across the Santa Maria River and into the town. Southern Pacific laid its tracks across the river on a temporary trestle. Riders could take the train into the Southern Pacific station in Guadalupe (shown here) on July 1, 1895. (Family of Nadine Grisingher Ferini and Dario Ferini.)

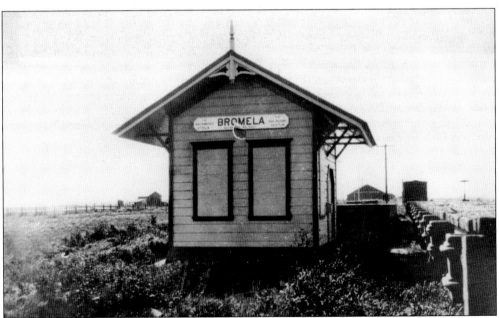

Many smaller stations lined the Southern Pacific route, including the Bromela station, which was located along the railroad just north of Oso Flaco Lake Road. Railroad stations like Bromela increased the value of the surrounding farmland by providing easier railroad access and, by extension, easier access to packinghouses and distant markets. (Bancroft Library, University of California, Berkeley.)

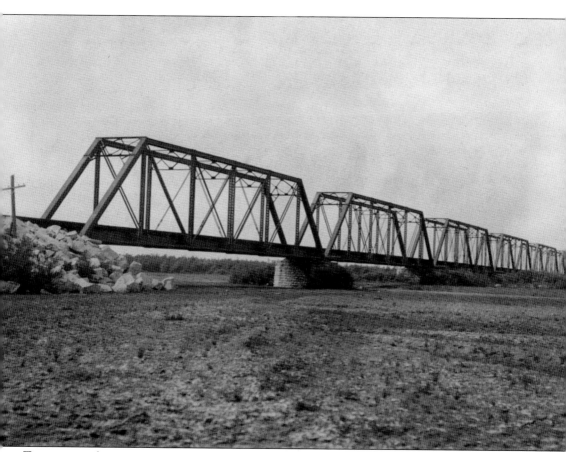

To maintain the momentum of construction, Southern Pacific began signing contracts for the erection of a permanent bridge across the Santa Maria River on the north end of town. Contracts were signed even prior to the completion of the temporary trestle, constructed to provide quick service to Guadalupe. Progress on the permanent bridge was slow. Over 300 men worked on the 1,283-foot steel structure, which was completed in June 1896. (Family of Nadine Grisingher Ferini and Dario Ferini.)

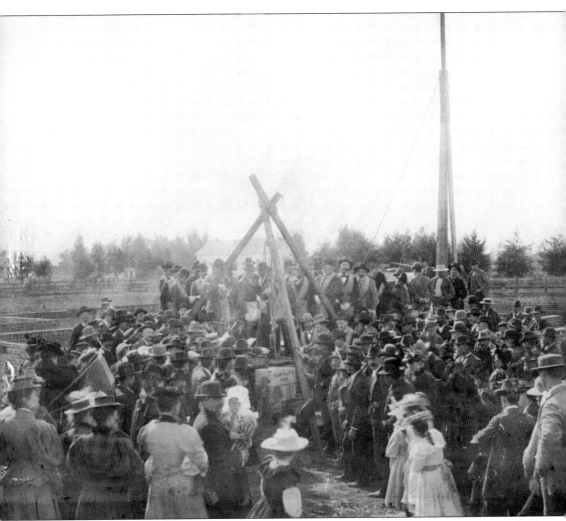

In 1896, Guadalupe's citizens decided they needed a new, larger schoolhouse with multiple classrooms to accommodate simultaneous classes. Local resident Stephen Campondonico held a position on the school board. Shown here is the groundbreaking ceremony, when the cornerstone was laid on March 7, 1896. (Rancho de Guadalupe Historical Society.)

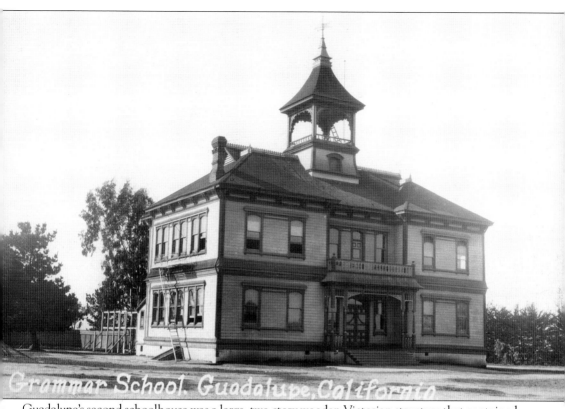

Grammar School. Guadalupe, California.

Guadalupe's second schoolhouse was a large, two-story wooden Victorian structure that contained a widow's walk and multiple classrooms. It served as the town's school until the late 1920s, when the third school was built at the same location. City Hall now stands on this site. (Family of Nadine Grisingher Ferini and Dario Ferini.)

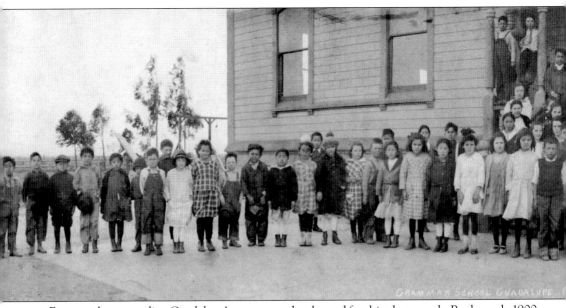

Every student attending Guadalupe's grammar school posed for this photograph. By the early 1900s, people of Native American, Mexican, Chinese, Japanese, Filipino, European, and American origin all called Guadalupe "home," as exemplified by the students who attended the many grade levels of Guadalupe School. Families from Guadalupe and the surrounding agricultural region all sent

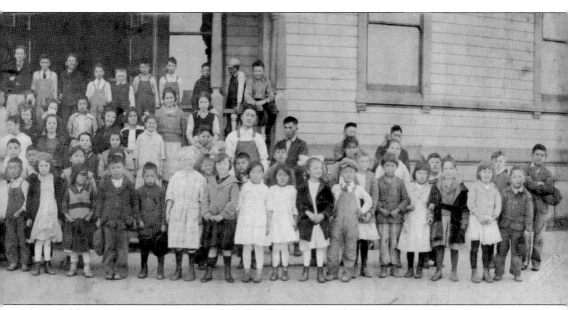

their children to the two-story Victorian schoolhouse, located near downtown. Every student in the region would have attended this school, given that the next closest schools were in Nipomo and Santa Maria. (Family of Nadine Grisingher Ferini and Dario Ferini.)

In 1887, Peter Ferini (left, c. 1935) immigrated to the United States from Switzerland. Family legend holds that he arrived carrying only "a loaf of bread, a hunk of cheese, a salami, and a bottle of wine." He worked on a nearby dairy farm and saved enough to purchase his own farm (above), located half a mile from the Southern Pacific Railroad. He married Irene Coppi, who immigrated to the United States in 1903 and worked as a domestic in the home of the Pezzoni family. (Family of Nadine Grisingher Ferini and Dario Ferini.)

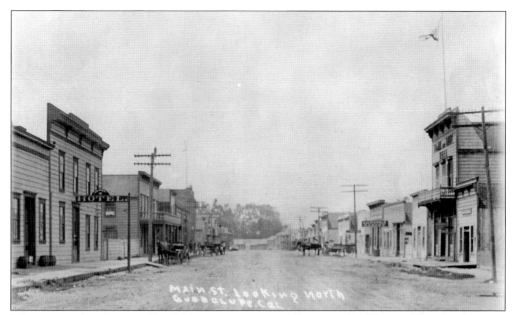

Like many railroad towns, Guadalupe sprang up virtually overnight. The resulting development is seen in this c. 1900 photograph. With the excitement from the arrival of the Southern Pacific Railroad, speculators sold land tracts in the town. Boosters dubbed Guadalupe "the Garden City" and promoted the region's agricultural potential. More people moved to Guadalupe than ever before. (Rancho de Guadalupe Historical Society.)

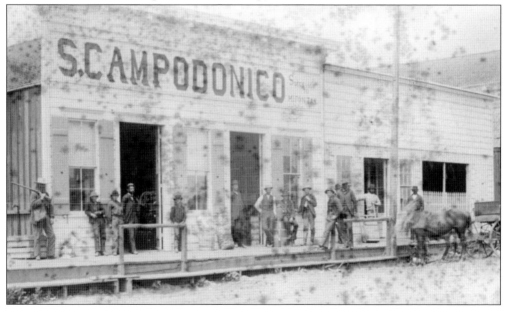

One of the people who made their way to Guadalupe was Stephen Campodonico. Born around 1840 in Italy, he arrived in San Francisco in September 1861. He lived on Fulton Street with his wife, Lizzie. Campodonico owned a marble yard and built marble structures in San Francisco. Through a series of events, he moved to Guadalupe while working for a creditor that foreclosed upon a store in the town. This establishment eventually became the S. Campodonico Store. (Rancho de Guadalupe Historical Society.)

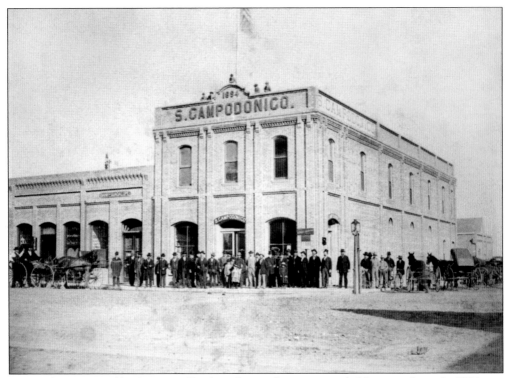

Due to the success of his business, Stephen Campodonico expanded his storefront. In 1927, one historian described the building as, "a substantial two-story and a basement structure which still stands as a monument to his progressive methods." It was the first brick building in Guadalupe, made from bricks created from clay excavated during construction. (Rancho de Guadalupe Historical Society.)

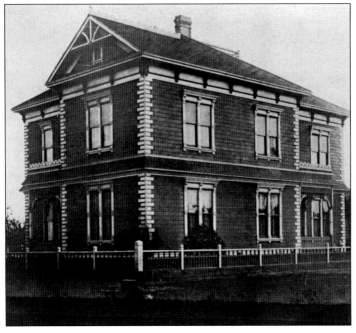

Perhaps the best known home in Guadalupe is the former Campodonico residence. According to an account published in 1927, Stephen Campodonico "erected a beautiful, modern residence, complete in all its appointments. His activities were linked inseparably with the development and upbuilding of Guadalupe." He helped plan the construction of the two-story school schoolhouse, Guadalupe Lodge, and Masonic and Odd Fellows Hall. (Rancho de Guadalupe Historical Society.)

San Francisco–based businessmen created the Union Sugar Company in September 1887 to represent the union of the sugar beet territories of San Luis Obispo and Santa Barbara Counties. The company built a mill near Guadalupe on the shore of Lake Guadalupe. It established the town of Betteravia for worker housing. The mill began operating in 1897, and the Southern Pacific built a branch from the main line to the factory. (Rancho de Guadalupe Historical Society.)

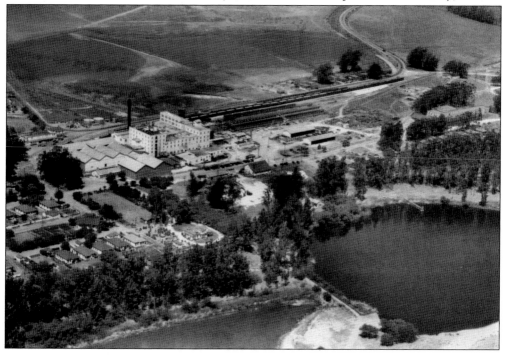

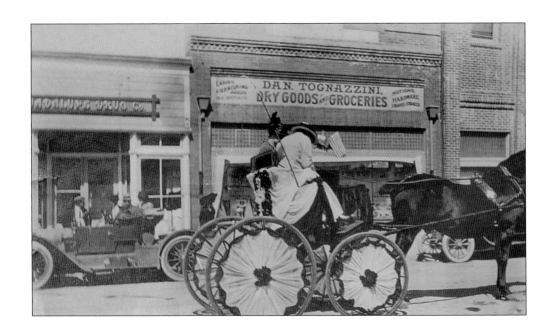

Dan Tognazzini, one of the children of the early Tognazzini homesteaders, opened a dry-goods store in Guadalupe. Above, a float passes in front of Dan Tognazzini's Dry Goods and Groceries. The community always enjoyed a good parade on many different occasions. Below, Dan and his wife pose in the shop, which contains immaculately displayed merchandise. (Susan Duran.)

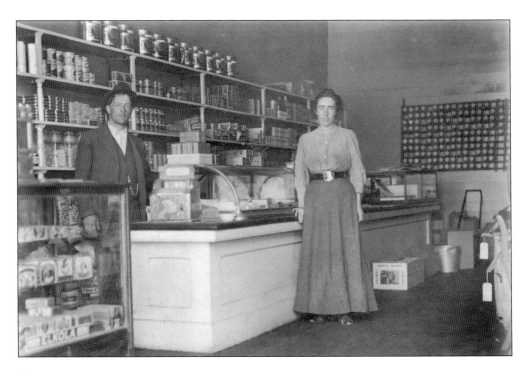

Marvin Tognazzini poses with the family dog, Casey, on a Guadalupe sidewalk in 1910. (Susan Duran.)

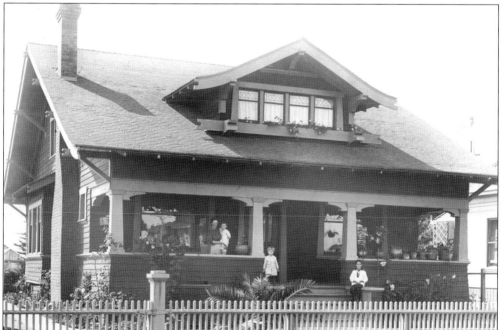

In 1912, Albert Grisingher built the Craftsman-style family home that still stands at 1055 Guadalupe Street in Guadalupe. It has been restored by the Dunes Center. This photograph was taken a few years after its construction. Pictured from left to right are Virginia Bassi Grisingher (holding Nadine Grisingher), Herbert Grisingher, and Dorothy Bassi. (Family of Nadine Grisingher Ferini and Dario Ferini.)

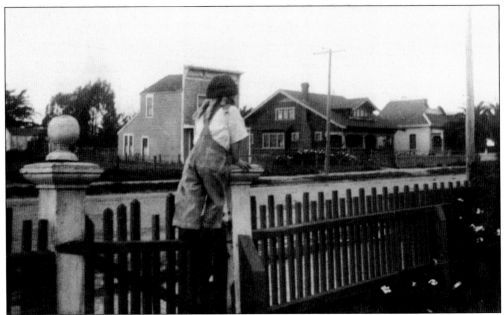

The main street that ran through Guadalupe eventually became Highway 1. The street has served as the main thoroughfare through town since the municipality's inception. Here, a child climbs on a fence along the street. The two-story structure across the street was eventually replaced, but the two buildings on the right still stand; they serve as the Guadalupe Cultural Arts and Education Center and the Dunes Center. (Dunes Center files.)

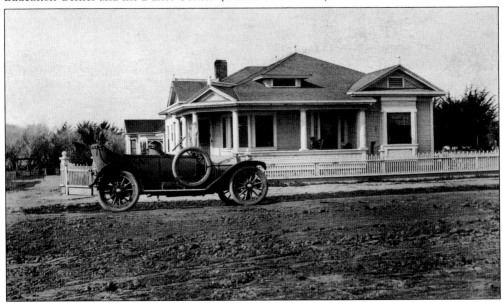

Paul Giacomini was born in Caton Ticino, Switzerland, in February 1876. He immigrated to the United States in 1896 and was, by all accounts, a true entrepreneur. Some records indicate that he was a partner in the early development of the Waller-Franklin Seed Company. Various censuses list him as the "town butcher" or a "cattle driver" who "worked on his own accord." The Giacomini home was built in the early 1900s. This photograph was taken at a later date, when cars were locally available. (Family of Nadine Grisingher Ferini and Dario Ferini.)

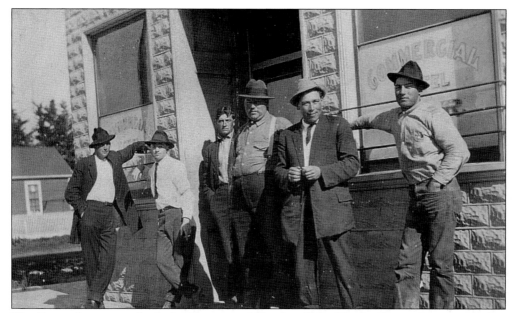

The Campodonico sons built the Commercial Hotel in 1912. Charles Campodonico worked in the mercantile business with his father. He later built the hotel with the help of brothers Frank and Stephen. One advertisement called the hotel "a splendid building, containing thirty-three rooms, and has been so managed as to become one of the most popular hotels in this section of the state." (Rancho de Guadalupe Historical Society.)

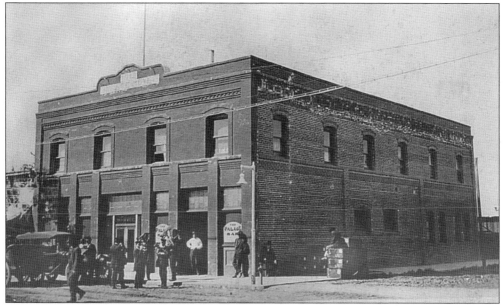

Also built in 1912, the Palace Hotel in downtown Guadalupe was opened by the Carenini and Forni families. In 1958, the Minetti and Maretti families acquired the building and opened the Far Western Tavern, which contained all of the original furnishing and fixtures, some of which was shipped around Cape Horn through the Drake Passage, according to local lure. The Far Western featured dishes that honored the region's Swiss-Italian ranch heritage. (Rancho de Guadalupe Historical Society.)

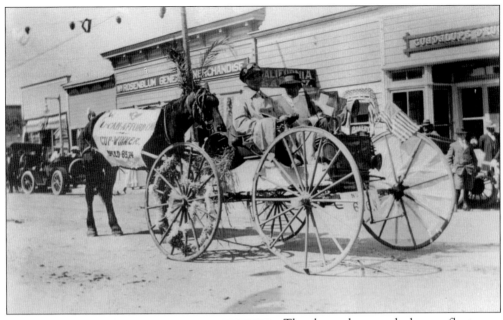

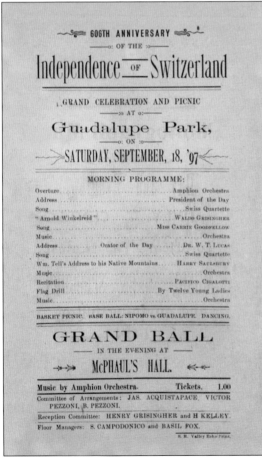

The above photograph shows a float in an early version of Guadalupe's Swiss Festival parade, driving down Guadalupe Street between Ninth and Tenth Streets in 1912. The prevalence of Swiss and American flags at the front of the carriage is evidence that this is the Swiss Festival parade. Festivals celebrating the area's Swiss heritage apparently began to take place early in the city's history, as indicated by the playbill at left from September 1897 celebrating the 606th anniversary of Swiss independence. (Above, courtesy of the Rancho de Guadalupe Historical Society; left, courtesy of the Guadalupe Cultural Arts and Education Center.)

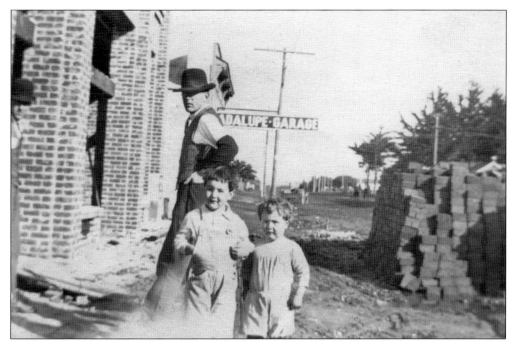

In 1913, the Odd Fellows built a new hall on Guadalupe's main street. Next to the new hall stood Guadalupe Garage, a service station for the first residents who owned cars. (Rancho de Guadalupe Historical Society.)

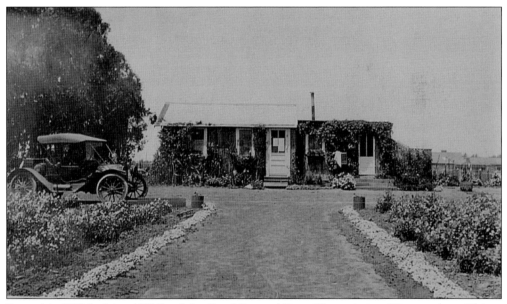

Started in 1913 by Lionel Waller, John Franklin, and Peter Giacomini on 30 acres along Obispo Street, the L.D. Waller Seed Company specialized in sweet pea flower seeds. Business was so great that production doubled, and the company expanded to begin hybridizing nasturtium. By 1927, the company was renamed Waller-Franklin Seed Company and sold 2,000 varieties of seed. The rich soil surrounding Guadalupe contributed to the company's success. (Rancho de Guadalupe Historical Society.)

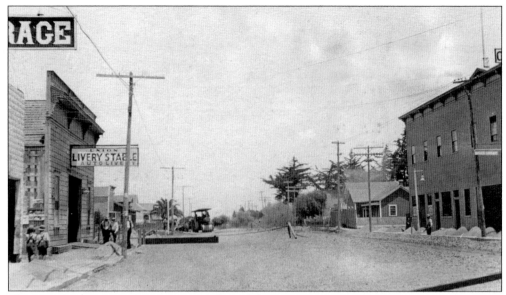

The year 1914 saw major improvement of Guadalupe's main street. The road was paved, making life easier for residents who desired a smoother trip and leading the way for the numerous cars that would be driving down California's Highway 1 in the not-so-distant future. (Susan Duran.)

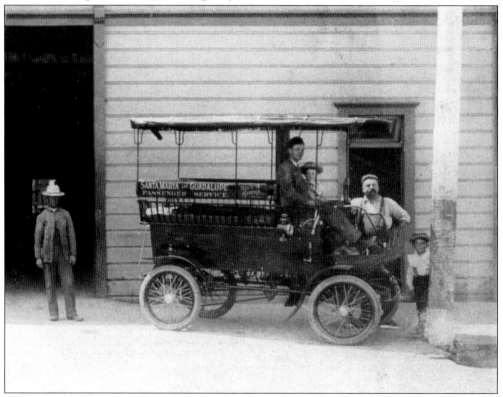

Passenger service between Guadalupe and Santa Maria provided an opportunity to travel between the cities and to the Southern Pacific Railroad for people living in Santa Maria. This particular car advertises Rice & Blosser. (Dunes Center files.)

Around the time Guadalupe's main thoroughfare was being paved, brothers Herbert (left) and Marvin Toganzzini posed for this photograph downtown. Construction appears to be taking place on the left, while the lack of traffic demonstrates Guadalupe's rural character. (Susan Duran.)

A group of men play bocci ball in a court that once faced the original Grisingher & Souza Store. (Rancho de Guadalupe Historical Society.)

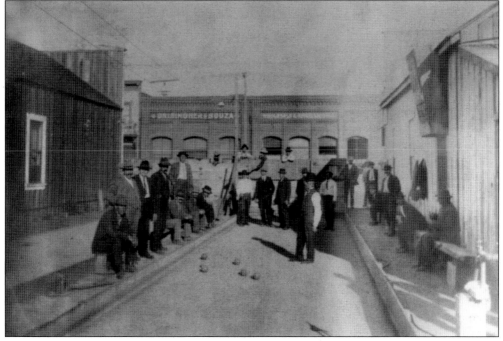

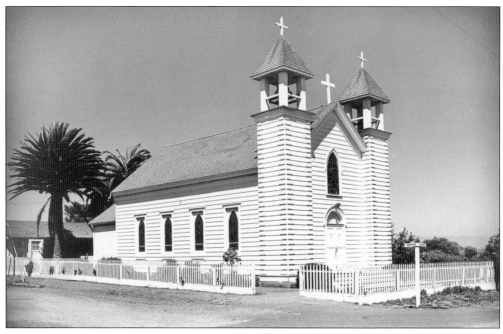

Guadalupe's churches and religious institutions demonstrate the community's diversity. Waves of immigrants, many of whom were agricultural workers, brought their religion with them. The city's founders were Catholic, laying the groundwork for later waves of Catholic immigrants, such as the Swiss-Italian and Portuguese transplants. Later immigrants built their own houses of worship. Pictured above is Our Lady of Guadalupe Church, named after the city's patron saint. To the left is Guadalupe's Buddhist church around 1915. (Above, the family of Nadine Grisingher Ferini and Dario Ferini; left, Rancho de Guadalupe Historical Society.)

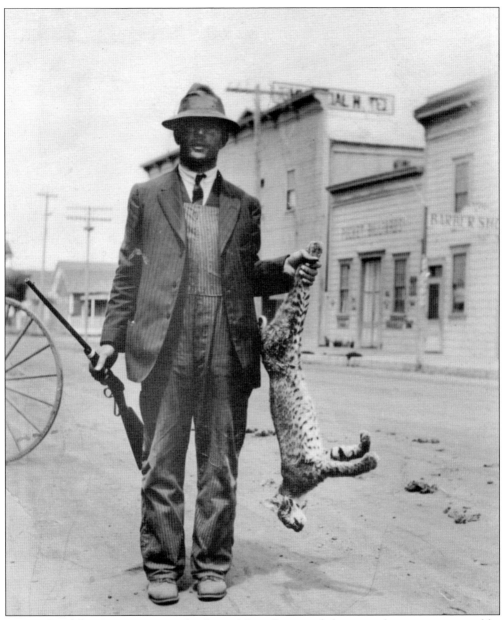

Due to Guadalupe's proximity to the Santa Maria River and the natural area encompassed by the Guadalupe-Nipomo Dunes, wild animals occasionally make their way through town. In 1916, Dan Tognazzini posed with a bobcat in front of the Commercial Hotel. (Susan Duran.)

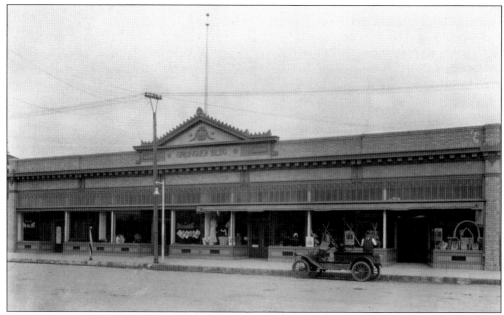

Built in 1916 by Peter Grisingher, the Grisingher Building is a brownstone structure that serves as an iconic Guadalupe landmark. The large building has housed various businesses throughout the years, including a sundries store, a market, a bowling alley, and possibly a tavern. Here, Antone Souza poses next to an automobile in front of the building. (Family of Nadine Grisingher Ferini and Dario Ferini.)

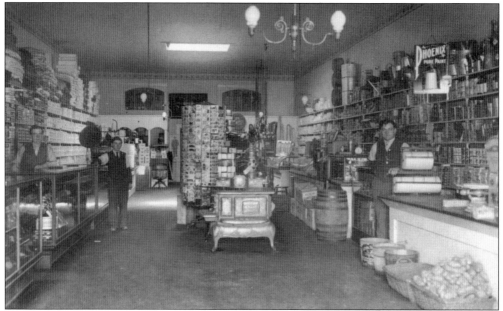

Antone Souza, a Portuguese immigrant from the Azores, joined Albert Grisingher to form the Grisingher & Souza Store. Souza, the largest lettuce grower in the Santa Maria Valley, also farmed beans and is credited with organizing the Independent Vegetable Growers of Guadalupe. From left to right are Grisingher, Olympio Belloni (a clerk), and Souza. (Family of Nadine Grisingher Ferini and Dario Ferini.)

Grisingher & Souza General Merchandise sold goods to local partners Enos & Munoz. The goods sold included everything from salami and cheese to a product called "Black Snake." (Dunes Center files.)

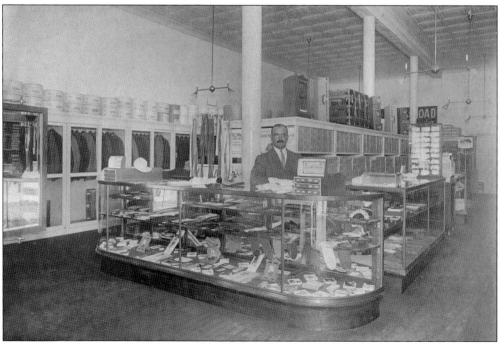

Another Grisingher family member worked as a merchant in Guadalupe. Henry Grisingher is seen here working at the counter of a neatly arranged mercantile store. Albert Grisingher took over Henry's business when he partnered with Antone Souza. (Family of Nadine Grisingher Ferini and Dario Ferini.)

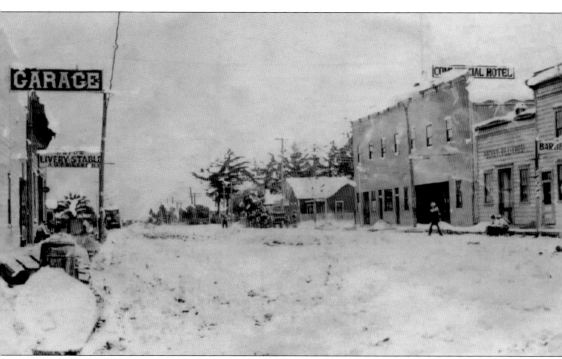

In the first half of the 20th century, a snowstorm hit Guadalupe. Spectators sit outside and enjoy the view, and a pedestrian braves the unusually cold weather. The low temperatures probably arrived to the dismay of the local agricultural community. (Rancho de Guadalupe Historical Society.)

Three

THE TURBULENT YEARS

In 1939, Marvin Tognazzini was searching Los Angeles for employment when he received a telegram from his brother, David. "Job Lined Up," the telegram read. "Think You Can Get Mine. Come Up."

The telegram from David to Marvin demonstrates the complexity of life during the interwar years. For some, the 1920s and 1930s were times of prosperity. For others, the period represented a dark time filled with racism and economic disaster. Regardless of the circumstances the people of Guadalupe faced during the period, the town's history is filled with stories of people uniting for the common good, demonstrating the resilience of the area's inhabitants.

Examples of Guadalupe's residents working together abound. Many served in the military during both world wars to fight for a better future. People came from around the world to work in local agricultural fields to feed the nation. It was during the 1920s and 1930s that many local families reached the pinnacle of their prosperity in the agricultural industry that represented the American Dream.

Examples of kindness can even be found in the darkest of stories. During Japanese internment, which heavily effected Guadalupe's residents, friends and neighbors occasionally helped those whom the government interned by keeping their property or maintaining their farms. Dorothea Lange encapsulated the complexity of life for Guadalupe's residents when she photographed them working in fields surrounding Guadalupe and then captured them interned in camps such as Manzanar a few years later.

The images in this chapter illustrate some of the best of times and some of the most difficult times that Guadalupe's population has faced. However, each photograph demonstrates hardy spirit and the ability to make the best of life even in the most tumultuous of circumstances.

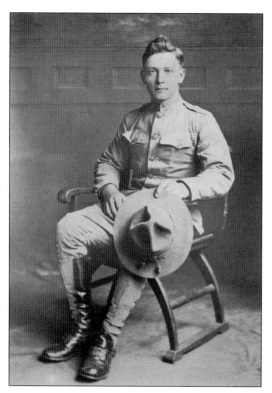

On June 5, 1917, Walter Earnest Tognazzini completed his draft registration card for World War I and enlisted in the military. According to the document, he worked at Union Sugar Company in Betteravia. Later in life, Tognazzini worked in the local oil industry. (Susan Duran.)

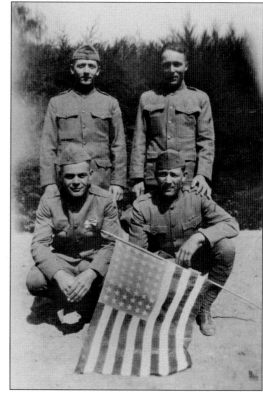

Several members of the Toganzinni family enlisted in the military during World War I. Posing with the 48-star American flag are, from left to right, (first row) Albert and Romeo; (second row) Walter Ernest and Grover. (Susan Duran.)

The Tognazzini family poses with the men of the family who enlisted in World War I. The timeless family scene contains both a dog and a baby refusing to cooperate with the photographer. (Susan Duran.)

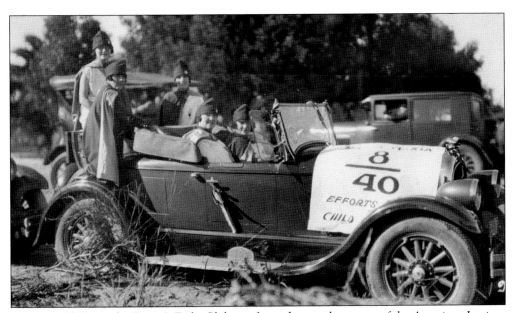

After World War I, the Forty & Eight Club was formed as an elite group of the American Legion. In 1922, the Forty & Eight emphasized fundraising for orphaned children, but by the end of the decade, the organization's fundraising expanded to include child welfare, junior baseball, patriotism, and emergency relief. Here, local Forty & Eight chapter members pose with a car during a parade in Pismo Beach in 1930. (Family of Nadine Grisingher Ferini and Dario Ferini.)

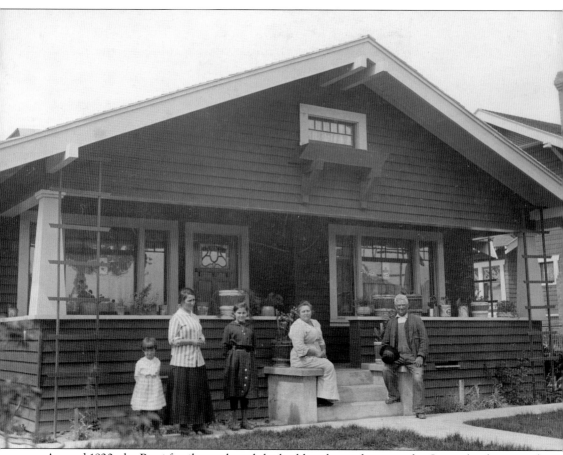

Around 1920, the Bassi family purchased the building located next to the Grisingher house and constructed a home similar to other nearby Craftsman-style structures. Pictured in front of the new building are, from left to right, Nadine and Virginia Grisingher and Dorothy, Augusta, and Antonio Bassi. The Dunes Center built a replica of the building in the same location in the early 2000s. (Family of Nadine Grisingher Ferini and Dario Ferini.)

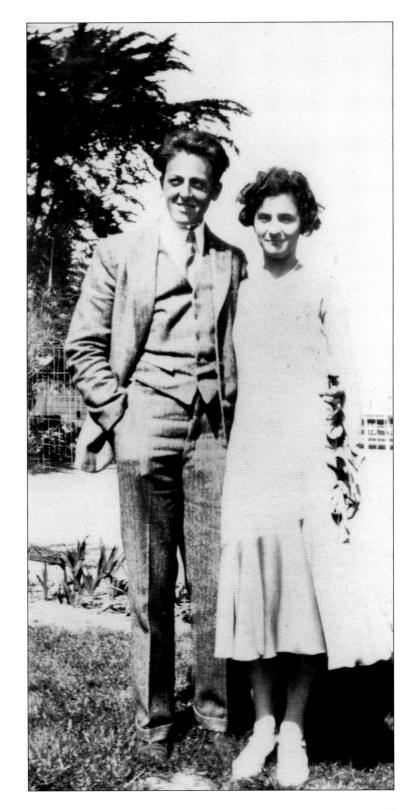

The Clem family poses for this 1920s photograph. Stan, born in Ohio, married Eva, a native Californian, in 1920. Stan was an electronics salesman and Eva was a stenographer at Guadalupe's utility company. (Family of Nadine Grisingher Ferini and Dario Ferini.)

From left to right, Eva Clem, Dorothy Bassi, and a woman known only as Elly pose for the camera. The original photograph contained the note, "Susie almost got left out," probably referring to the bulldog joining the group on the left. (Family of Nadine Grisingher Ferini and Dario Ferini.)

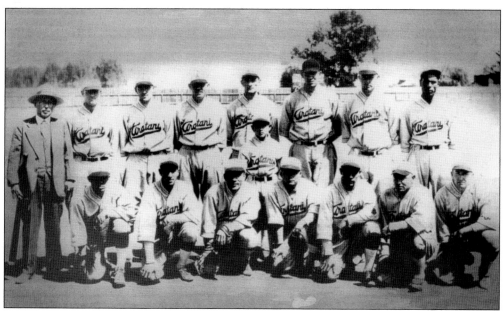

Setsuo Aratani (above, far left; below, third from right) immigrated to the United States from Japan around the turn of the century. Aratani did well for himself as a farmer with an education. Eventually, some called him "The Lettuce King." He owned a baseball team that traveled around California, eventually playing in Japan in 1929. Aratani's team took pride in the fact that it was integrated and that it reflected the area's demographics. His love of baseball spilled over into his agricultural businesses, with sayings such as "Safe at Home" and "Home Run King" appearing on his vegetable packing labels. Above, the team is pictured at an unidentified location. Below, the team is on a ship heading to Japan. (Ernest De Gasparis.)

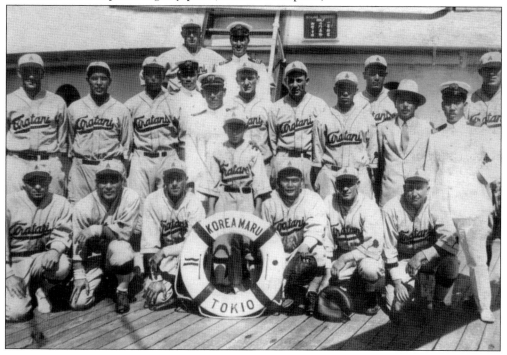

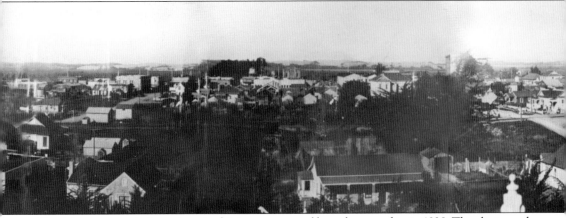

Guadalupe appears in its entirety in this image captured by a photographer in 1928. The photograph was possibly taken from atop the old Victorian schoolhouse just prior to its replacement in 1929, as can be deduced from the decorative element in the bottom center portion of the photograph,

possibly part of the railing of the widow's walk. The original Our Lady of Guadalupe Church, covered in clapboard, is on the left. The Campodonico home is at center. The Guadalupe-Nipomo Dunes Complex is visible on the horizon of the entire photograph. (Ernest De Gasparis.)

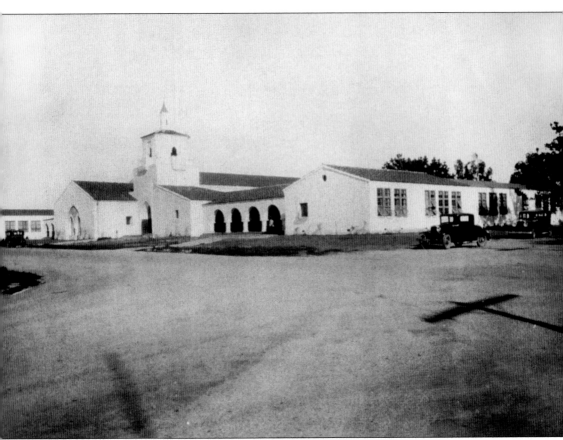

Inspired by the Mission Revival style of architecture that gained popularity in the United States during the 1920s, Guadalupe's grammar school was updated in 1929 at a cost of $105,000. According to a brochure published by Guadalupe's Progressive Club in the 1930s, the school contained 12 classrooms, a library, a manual training program, a clinic, a domestic science program, a kindergarten, and administrative rooms. This was in addition to an auditorium with seating for 750 and a stage that was "an incentive for amateur theatrical productions which furnish excellent outlet for speaking and dramatic expression of untold benefit to the pupils." The building would later become City Hall. (Dunes Center files.)

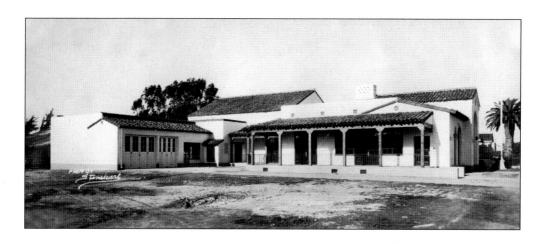

Taken in 1932, these photographs show the building that houses the Guadalupe American Legion, which still operates there today, along with the Rancho de Guadalupe Historical Society and the city's fire department. Veterans returning from World War I founded the American Legion. Many legion halls were built in the 1930s. The organization reached one million members in 1931. The American Legion in Guadalupe was constructed in front of the Rancho de Guadalupe adobe homes, seen on the left side of the above image. Below, Augusta Bassi sits on the front steps of the building. (Family of Nadine Grisingher Ferini and Dario Ferini.)

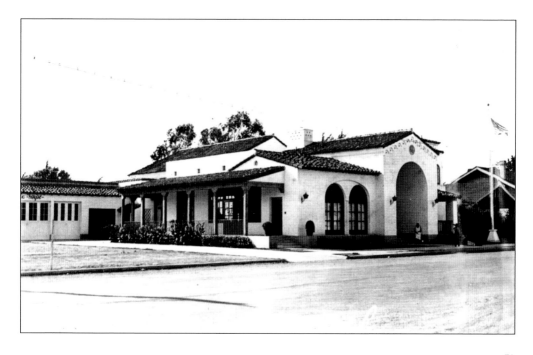

The entire Grisingher family was excited about their presumably new car purchase, a Ford Coupe. In the photograph to the left, Herb Grisingher proudly poses in front of the car. Below, from left to right, Nadine Grisingher, Augusta Scheifferly-Bassi, and a woman identified only as Jean stand in front of the vehicle. (Family of Nadine Grisingher Ferini and Dario Ferini.)

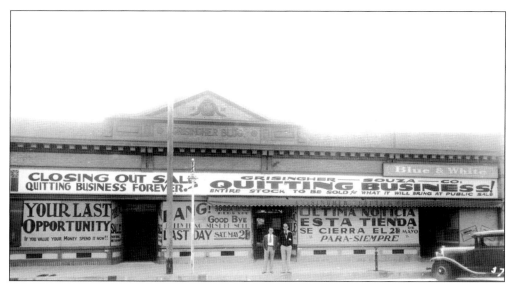

In 1933, the Grisingher & Souza Store closed its doors. The signs blanketing the storefront provide a glimpse into Guadalupe's multiculturalism, as everything is printed in both English and Spanish. Here, Joe Olivera (left) and Herb Grisingher pose in front of the Grisingher building. (Family of Nadine Grisingher Ferini and Dario Ferini.)

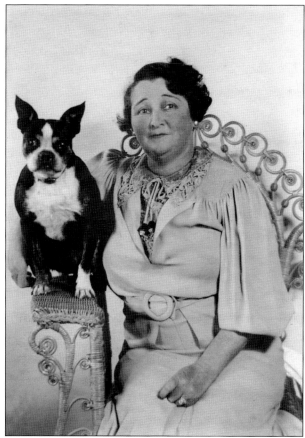

Virginia Bassi Grisingher poses with her bulldog, Betty, in 1936. (Family of Nadine Grisingher Ferini and Dario Ferini.)

Guadalupe THE Garden City

The Southern Pacific Gateway to the
Santa Maria Valley.

Soon to be a unit of the Scenic Coast Route paved highway, parallelling the
ocean from San Francisco to San Diego.

One of the finest vegetable and dairy sections on the coast and home of the
largest flower seed company in the world.

EXCELLENT CLIMATE—WATER—SCHOOLS—BANKING FACILITIES

GUADALUPE SUBDIVISION NO. 1

Facing on the main boulevard, offers excellent residence and business sites
fully improved and safely restricted. Also excellent soil with water, just of
the boulevard in two and ten-acre tracts. Fine income property with
growing valuation.

In an effort to promote the local economy, boosters dubbed Guadalupe "The Garden City" to
bring people to a new subdivision via Highway 1, which was being paved through government
programs. (Family of Nadine Grisingher Ferini and Dario Ferini.)

Prior to the 1964 state highway renumbering, what is currently Highway 1 was a series of disconnected roads along the California coastline that were built in a piecemeal manner. The road south from Pismo Beach was paved in the 1930s and received the official title of Highway 1 in 1934. (Caltrans.)

Maint. Culv. in Guadalupe before extension. 4-23-36

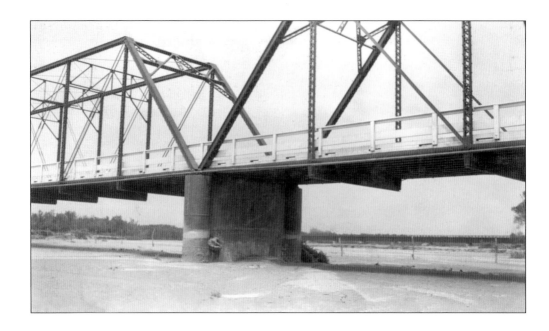

Paving what would become Highway 1 involved construction on the Santa Maria River Bridge, leading into Guadalupe from the north. Thanks to photographs such as these, by which Caltrans documented the construction project, the state agency has a rich collection of images of California's transportation history. (Caltrans.)

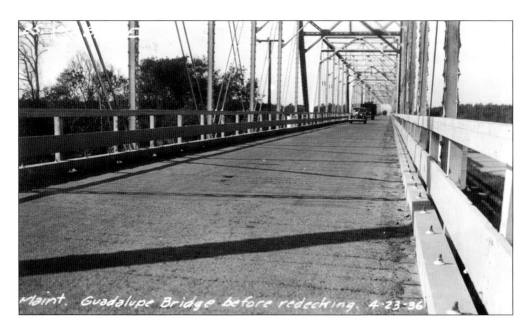

The building of roads allowed travelers to pass through Guadalupe, including the Historic American Building Survey crew, who took photographs of the historic adobe structures that once stood in Guadalupe. Government employees who received jobs as part of the New Deal effort to increase employment of architects and engineers took photographs and created blueprints. These provide a rare look into the structures that once stood in Guadalupe. (Library of Congress.)

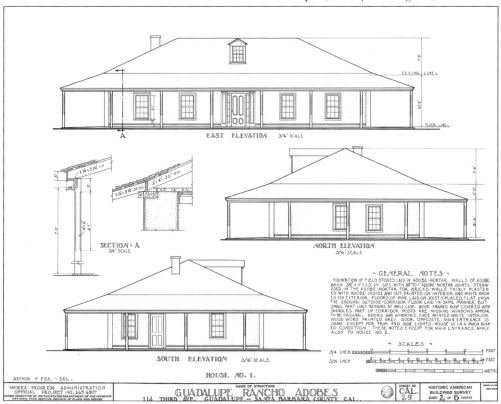

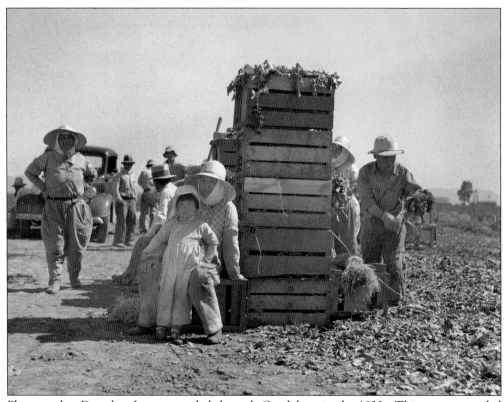

Photographer Dorothea Lange traveled through Guadalupe in the 1930s. This image, entitled "Japanese Agricultural Workers Packing Broccoli near Guadalupe," captures the multicultural workforce that called Guadalupe home for at least part of the year. (Library of Congress.)

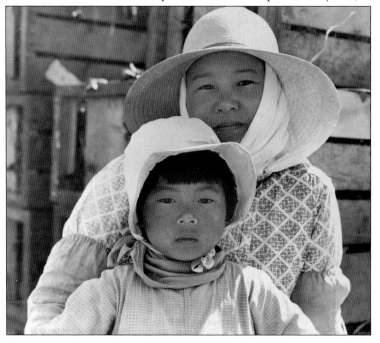

Much like Dorothea Lange's famous "Migrant Mother" photograph, captured in nearby Nipomo, this image captures the life of a mother caring for her child while working in the agriculture industry during the Great Depression. Lange visited the Central Coast on several occasions in the 1930s while documenting life for the WPA's Farm Security Administration. (Library of Congress.)

Some believe this Dorothea Lange photograph depicts a Filipino worker in a field outside of Guadalupe. Labor recruiters encouraged Filipinos to immigrate to the United States during the 1920s and 1930s, because strict immigration laws prevented foreigners from coming to the United States. The Philippines was an American possession at the time, meaning Filipinos could come freely. However, they still faced discrimination and lacked many of the rights associated with being an American citizen. (Library of Congress.)

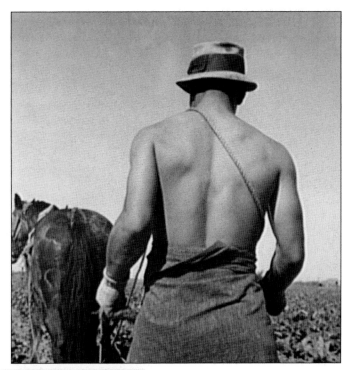

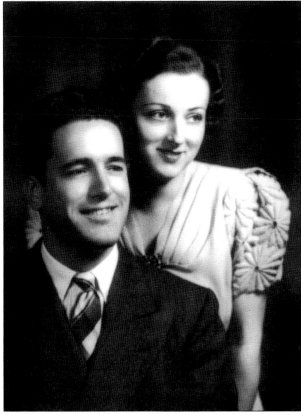

Not all was bleak during the Great Depression. In fact, there were times for celebration, including the marriage of Dario Ferini to Nadine Grisingher on June 12, 1938. The couple is pictured in their wedding portrait. (Family of Nadine Grisingher Ferini and Dario Ferini.)

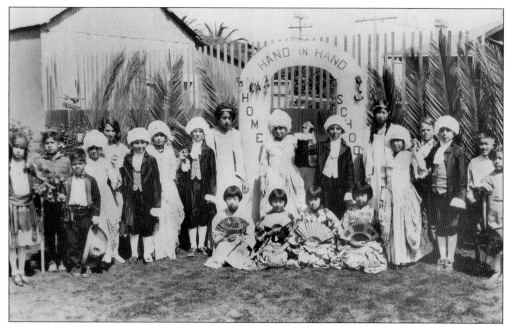

Elementary schoolchildren from Hand in Hand Home School pose for a day of celebration. The children dressed up in clothing representing the region from which their family originally immigrated, demonstrating Guadalupe's diversity. (Ernest De Gasparis.)

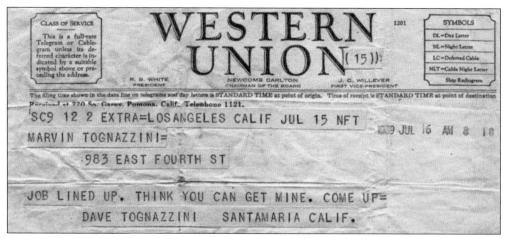

In 1939, Marvin Tognazzini was unemployed and left his family to search for a job in Los Angeles. His younger brother, David, because he had no family to support as Marvin did, gave up his job at Five "C" Refinery so that Marvin would be fully employed. David sent this telegram to Marvin in Los Angeles to let him know his job was available. (Susan Duran.)

The Commercial Hotel is pictured here in the 1930s or 1940s. According to locals, the hotel was the "happening place," where most large community social gatherings took place, due to the limited number of other local large venues. The hotel was the site of Saturday night dances attended by young people. (Ernest De Gasparis.)

A large funeral took place in Guadalupe around 1940, possibly that of Sedsuo Aratani, Guadalupe's "Lettuce King." A service at the Buddhist church was followed by a procession through downtown Guadalupe and a burial at the cemetery. (Ernest De Gasparis.)

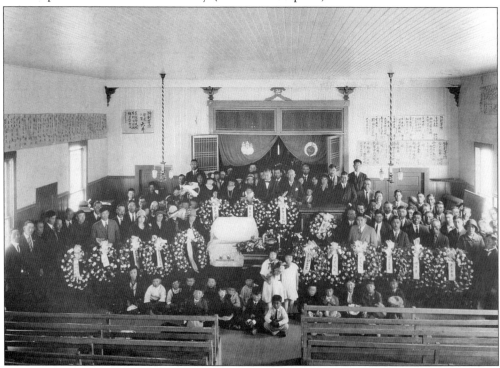

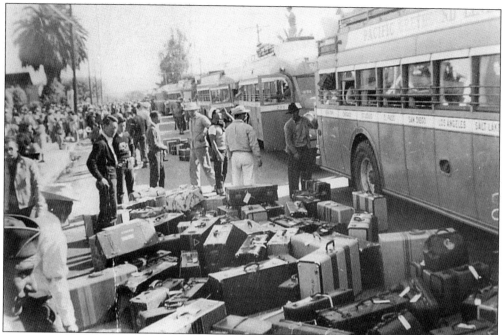

In the wake of the bombing of Pearl Harbor, on February 19, 1942, Franklin Delano Roosevelt issued Executive Order 9066. The order created exclusionary zones along the West Coast from which everyone of Japanese ancestry was forced to move into relocation camps. Of the over 100,000 evacuees forced to move, a large majority were American citizens. People of Japanese ancestry living in Guadalupe at the time had to pack everything they owned into suitcases and board buses to Tulare, where they were dropped off at a temporary holding station. (Rancho de Guadalupe Historical Society.)

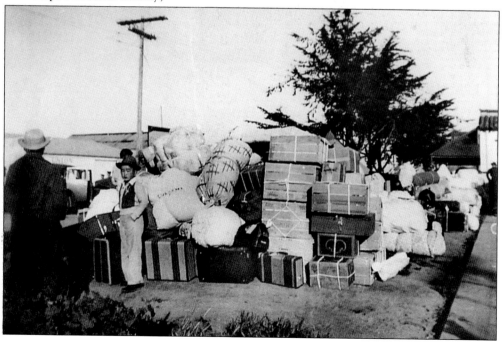

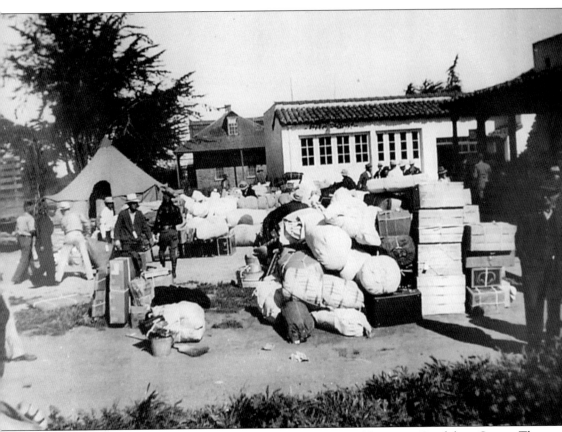

In the spring of 1942, everyone of Japanese descent awaited buses on Guadalupe Street. They were allowed to bring only the items they could carry. Given 72 hours' notice, they were forced to sell their homes, farms, and other valuables. Guadalupe's First Buddhist Church served as the boarding station, but the line stretched down the street. Here, the American Legion parking lot, with the Guadalupe adobe home in the background, apparently served as a loading station for personal belongings. (Rancho de Guadalupe Historical Society.)

On her travels around the country, photographer Dorothea Lange ran into Guadalupe residents, often outside of the city. Lange captured this image of Ted Ichiji Akahoshi at the Manzanar Relocation Center. According to Lange's notes, Akahoshi was chairman of the Block Leader Council at Manzanar and a former truck farmer. He had three American-born children who were also in the camp, ages 17, 21, and 22. According to Manzanar documents, the relocation center was only a temporary location for Akahoshi, with his final destination being a relocation camp in Granada, Colorado. (Bancroft Library, University of California, Berkeley.)

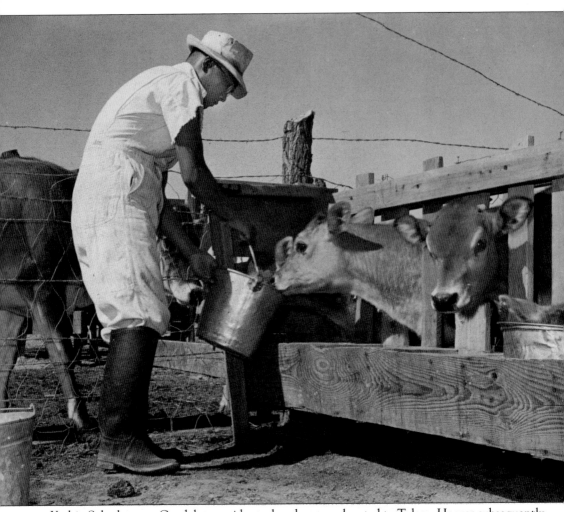

Yoshio Sakoda was a Guadalupe resident when he was relocated to Tulare. He was subsequently moved to internment camps in Gila Rivers, Arizona, and Tule Lake, California. Photographer Francis Stewart worked for the War Relocation Authority and captured images such as this of Sakoda at Gila Rivers. His notes indicate that Sakoda was a vegetable worker from Guadalupe who enrolled in dairy school at the camp. (Bancroft Library, University of California, Berkeley.)

When Francis Stewart left the War Relocation Authority, Hikaru Iwasaki eventually replaced him after working as a darkroom assistant. Iwasaki became known for his photographs of "the Salvage," Japanese Americans who left the internment camps before the war was over. Many of these photographs show Japanese Americans contributing to the good of society, such as Guadalupe resident Francis Ichikawa (right), who was hired by Clark's Salad Dressing Company in Des Moines, Iowa. The caption of this photograph reads "Mr. Ichikawa is quite happily situated and likes his work very much." (Bancroft Library, University of California, Berkeley.)

Photographer Hikaru Iwasaki sought to depict uplifting moments in an otherwise demoralizing societal environment in which Japanese Americans were imprisoned and racism ran rampant. Iwasaki took this photograph of Dr. Howard Suenaga, a physician formerly from Guadalupe. According to the image's caption, Suenaga led 35 Japanese Americans to volunteer to give blood to the American Red Cross and protest against the treatment of American troops by the Japanese in the Philippines during World War II. Suenaga is pictured with Margaret Plotkin, a third-generation Japanese American, or Sansei. (Bancroft Library, University of California, Berkeley.)

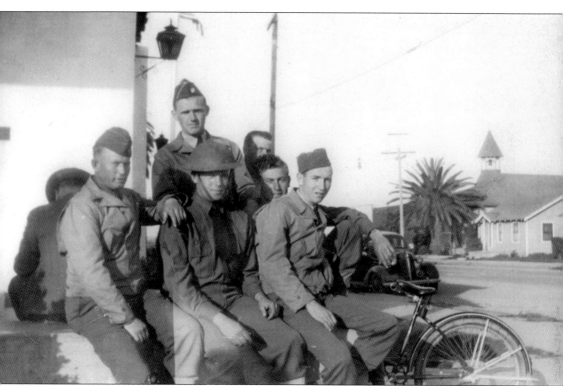

Many of Guadalupe's finest served during World War II, including, from left to right, Captain Smith, Private C. Schlaegel, B. Whaley, Les Whaley, Corporal Bishop, and Pvt. Ed Young, all of whom are posing at the Veterans Building. The men, part of the 140th Infantry, were on leave in January 1942. (Rancho de Guadalupe Historical Society.)

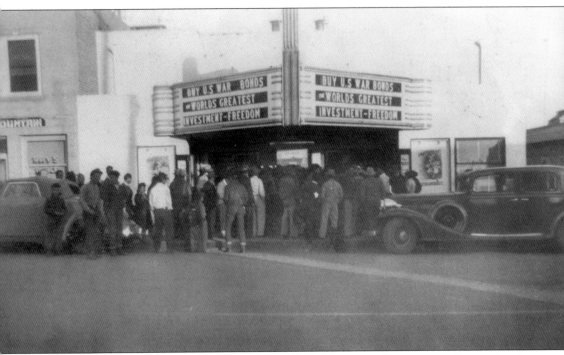

Constructed in 1939, the Japanese-built Royal Theater is an Art Deco movie theater that has hosted numerous screenings of locally shot films. Here, men line up in front of the theater. The marquee advertises the sale of war bonds in 1940. (Rancho de Guadalupe Historical Society.)

Four

THE GUADALUPE-NIPOMO DUNES COMPLEX

"The farther she walked, the more she was enticed by the soft, rolling mounds of sand that seemed to be mystical extensions of the ocean's waves," author Virginia Cornell wrote in a biography of early local environmentalist Kathleen Goddard Jones. Cornell continued, "She had never seen such a happy ocean/shore connection."

It is not only Jones who was taken aback by the awesome terrain of the Guadalupe-Nipomo Dunes. For thousands of years, native peoples survived using locally available resources. By the late 1800s, flurries of tourists discovered the Dunes, paving the way for businesses. The Southern Pacific Railroad arrived and, four years later, an ornate Victorian pavilion opened between Oceano and Oso Flaco, with a pier to welcome passing ships. Real-estate speculators subdivided portions of the Dunes and sold them to buyers who wanted to purchase a piece of the scenic oceanfront property. They were unaware that their newly acquired land was located on quickly shifting sand and had no access road.

Thousands of years of mineral movement from the nearby mountains by the Santa Maria River formed the recreational area that is today's Guadalupe-Nipomo Dunes Complex. The rock cycle and the shape of the coastline formed the various ecosystems that flora and fauna call home, along with one of the largest dune systems in the United States, containing some of the tallest coastal sand dunes on earth. The complex geologic process also formed the places in which locals and tourists spend their free time, doing everything from picnicking and sunbathing to clamming and driving on the Dunes.

A large portion of the Guadalupe-Nipomo Dunes Complex is still open to the public for recreational purposes, thanks to individuals like Kathleen Goddard Jones. Various individuals and local, state, and federal agencies have worked together to continue the tradition of dune recreation and usage that began with the local Native American groups, while simultaneously protecting the plant and animal species that rely on the Dunes for their survival.

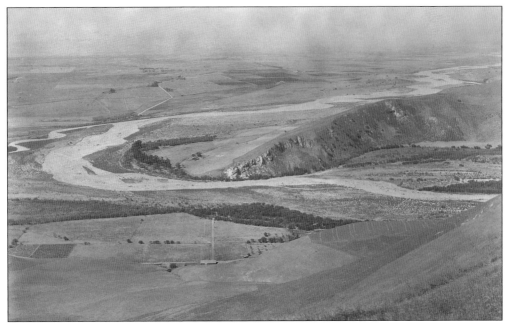

This late-19th-century photograph shows the area where the Cuyama and Santa Maria Rivers meet. Thousands of years of river and sediment flow brought sand down the Santa Maria River. The sand was eventually washed ashore, forming the beaches between Pismo Beach and Point Sal. Thousands of years of sand flow also formed the Nipomo Mesa, which is an example of a stabilized dune. (Dunes Center files.)

A horse and wagon is on the beach in the late 1800s. The photograph looks south from Pismo Beach. Tourist attractions in Pismo Beach and the Oceano Pavilion are visible in the distance. Written on the back of this photograph is: "Sand same as card. Water colored green and white. Rock brown and gray. Sky blue and yellow tinted." (History Center of SLO County.)

In 1895, outdoor enthusiasts enjoy Black Lake, one of the many gems in the Guadalupe-Nipomo Dunes Complex. Freshwater lakes are located throughout the complex, a result of the level of the water table and the sediment, which prevents fresh water from draining elsewhere. Water like this has allowed plants, animals, and people to survive and prosper in the dunes for thousands of years. (South County Historical Society.)

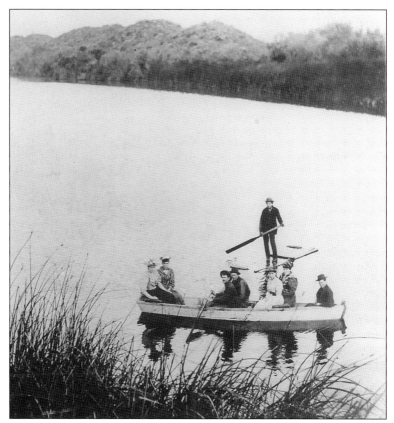

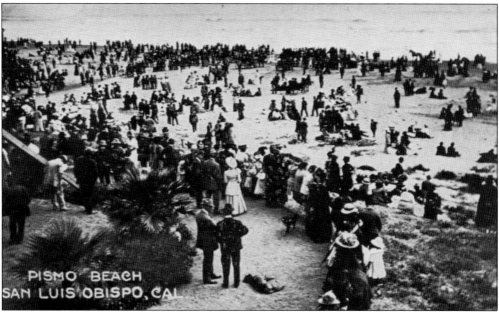

Pismo Beach experiences a crowded weekend, with many merrymakers attending festivities in their finest beachwear. Some visited the beach with their horses, while others brought their dogs. All were there to have a good time. (History Center of SLO County.)

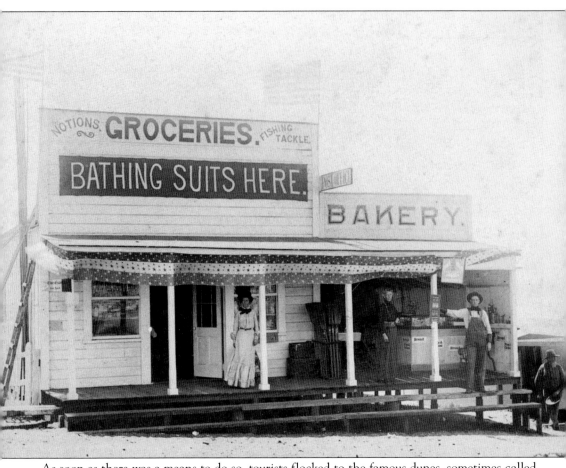

As soon as there was a means to do so, tourists flocked to the famous dunes, sometimes called the Pismo Dunes, the Oceano Dunes, or the Guadalupe Dunes. Land speculation was spurred by the Southern Pacific Railroad. Visitors came for the weekend. Many saw the opportunity to make a living by selling goods and services. This practice continues today with the concessionaires located along the complex. (History Center of SLO County.)

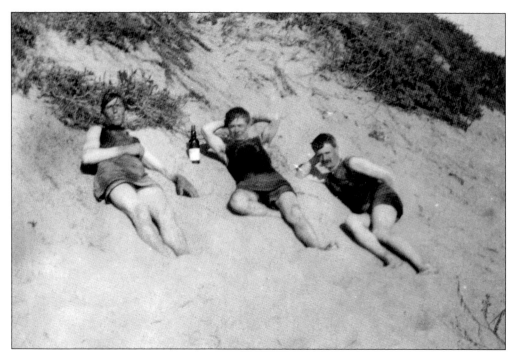

These men enjoy a beverage at the Dunes in 1906. In the early 20th century, men's bathing suits began to expose more of their bodies, as swimming gained in popularity as a sport. The sleeveless tank suit with knee-length pants replaced the shirts and trousers that were once considered appropriate. (History Center of SLO County.)

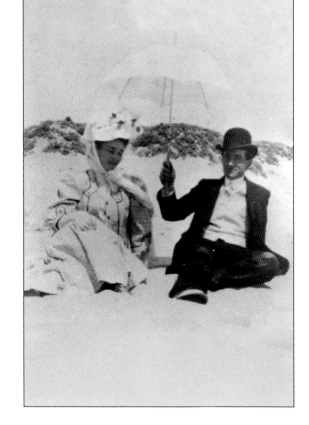

The Guadalupe-Nipomo Dunes Complex not only attracted out-of-town visitors; many locals spent their leisure time at the beach. Virginia and Albert Grisingher posed for this photograph during a day at the beach in 1908. (Family of Nadine Grisingher Ferini and Dario Ferini.)

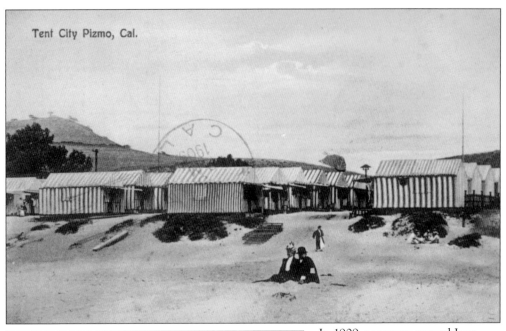

Tent City Pizmo, Cal.

In 1909, a woman named Jean sent a postcard to her friend, Marie Nichols, expressing her sadness that her friend could not join her on a vacation in Pismo Beach, particularly for the Fourth of July, which was "Big Time." The postcard image shows the tents that visitors to Pismo Beach could stay in while visiting the Dunes. (History Center of SLO County.)

In 1911, this unidentified woman posed for a photograph on a "sand hill" in her finest beachwear. While the main aspects of bathing suits changed little from year to year in the early 1900s, trimmings and other details varied. Most bathing-suit patterns included a blouse, knickerbockers, and a skirt. Women wore shorter skirts when going into the water, but longer skirts when on the shore. (History Center of SLO County.)

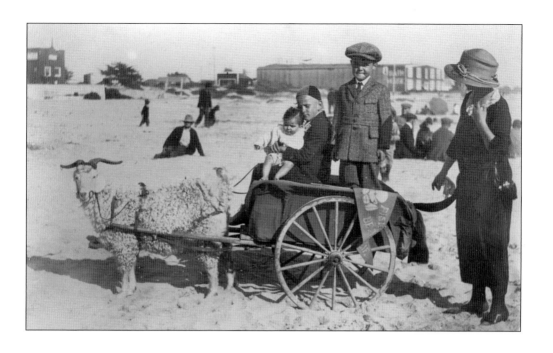

People of all ages have enjoyed leisure time at the Guadalupe-Nipomo Dunes Complex. Above, a little boy in a suit and a flat cap stands with two other children in a cart pulled by a white goat. A woman in a black dress behind the cart watches the children as they pose for the photograph, which was taken near the tourist area in Pismo Beach. Below, the crowd at Pismo Beach appears to be watching an event taking place on the north side of the beach in a photograph dated May 23, 1915. (History Center of SLO County.)

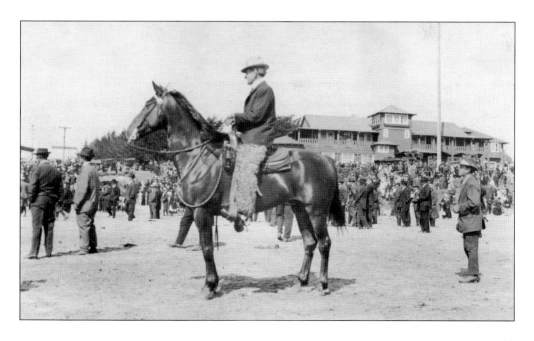

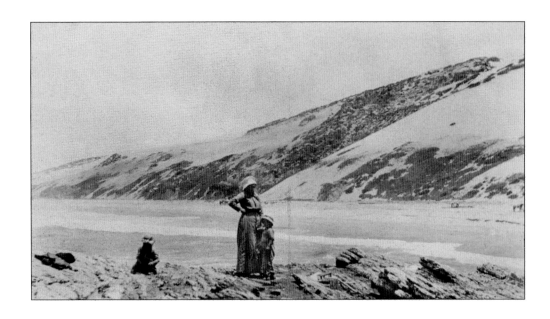

The southern portion of the Guadalupe-Nipomo Dunes Complex contains Mussle Rock, the location of many of the tallest sand dunes in the world, some of which are 500 feet tall. Above, from left to right, Hetty, Leona, and Marvin Tognazzini picnic at Mussel Rock with large sand dunes in the background. Below, unidentified beachgoers enjoy Mussle Rock. Both photographs are dated 1914. (Above, Susan Duran; below, Rancho de Guadalupe Historical Society.)

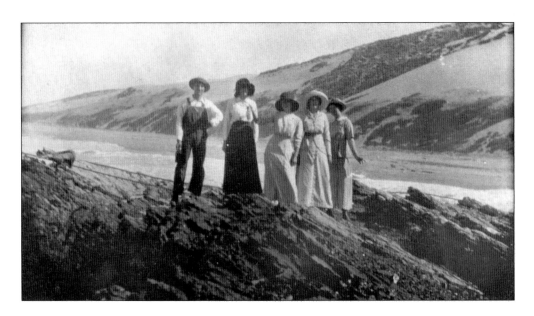

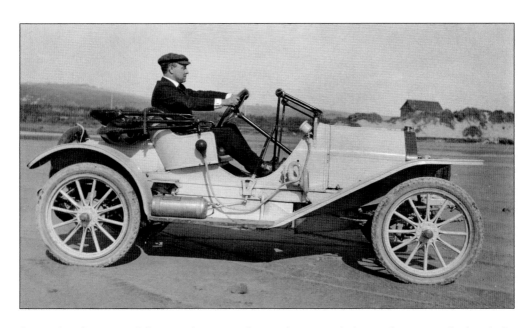

Soon after the automobile started to see widespread use, people began driving on the beach. In the early days, recreational visitors simply deflated the tires on their regular cars to keep from getting stuck in the sand. (History Center of SLO County.)

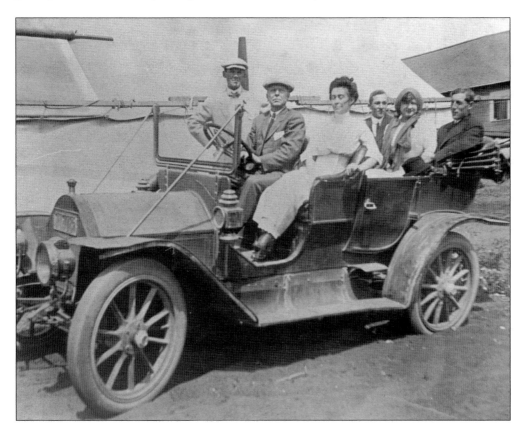

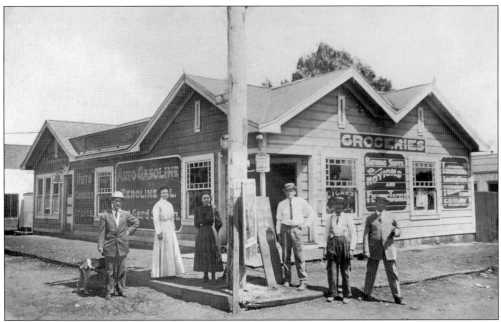

As the complex's recreational uses expanded and changed, so did the types of goods and services offered to tourists. Earlier photographs indicate that bathing suits and baked goods were for sale. This photograph indicates that in the 1910s, gasoline was a main commodity at a store called The Emporium in Pismo Beach. (History Center of SLO County.)

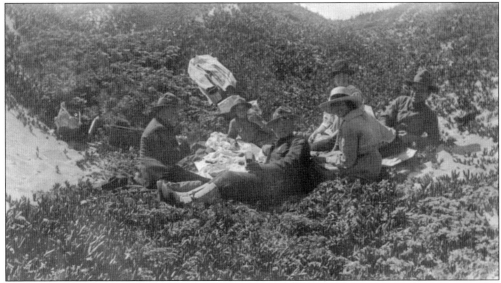

Local ladies, including Virginia Aquistapace (in white hat), picnic with enlisted men during World War I. America's limited involvement in the war resulted in many local residents being called for duty in 1917. However, the war was over by 1919, so these men may have been on leave when this c. 1918 photograph was taken. Surrounding the group are ice plants. The invasive species became prominent after settlers brought the plants with them for landscaping and erosion prevention. (Rancho de Guadalupe Historical Society.)

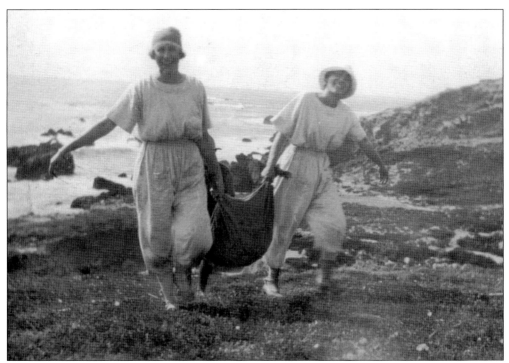

Aida (left) and Virginia Aquistapace carry mussels collected from Mussel Rock. They are wearing their work clothes in this c. 1920 photograph. (Rancho de Guadalupe Historical Society.)

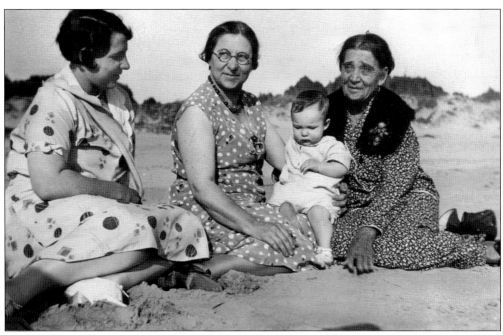

Four generations of the Twitchell family relax in the Dunes. From left to right are Edwina Zunetti Twitchell, Anita Zunetti, Maurice Twitchell, and "Aunt Lizzie." The family name was lent to the Twitchell Dam. (Family of Nadine Grisingher Ferini and Dario Ferini.)

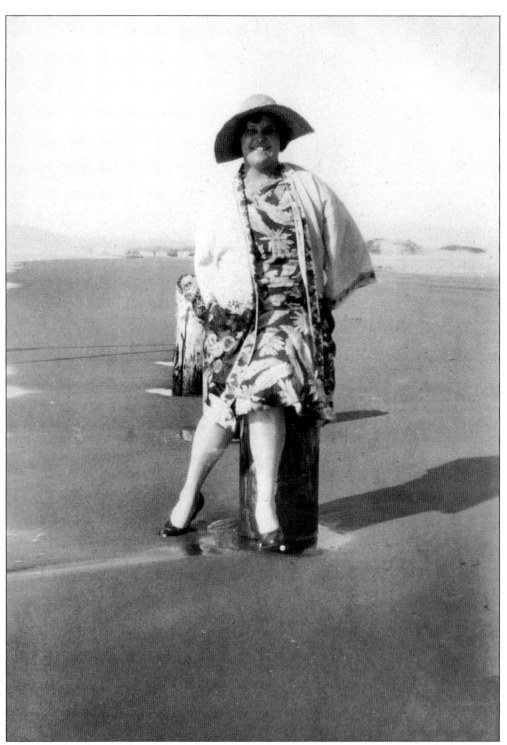

Dorothy "Dot" Bassi is pictured sitting on an abandoned pier post near Oceano during a family outing in March 1931. This photograph is entitled "Madam Goofina." (Family of Nadine Grisingher Ferini and Dario Ferini.)

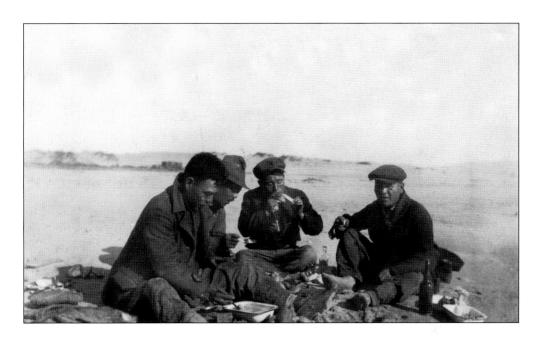

In these 1930s photographs, a Mr. Wakimoto (second from left), Hachijuro "Charlie" Maenaga (third from left), and their companions enjoy baked clams collected in the Dunes. Maenaga immigrated to the United States from Japan in 1905 and worked as a buyer in a local vegetable packinghouse, according to the 1930 census. The northern end of the dunes complex was known for its particularly large clams, which were collected and sold in Guadalupe by horse and buggy. (Maenaga family.)

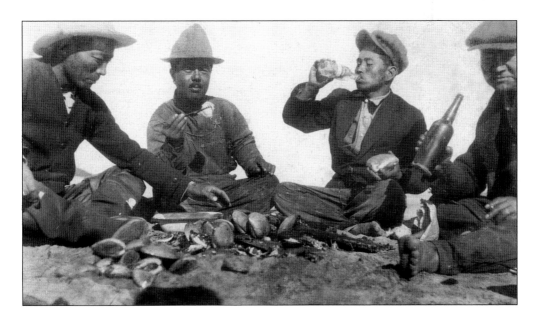

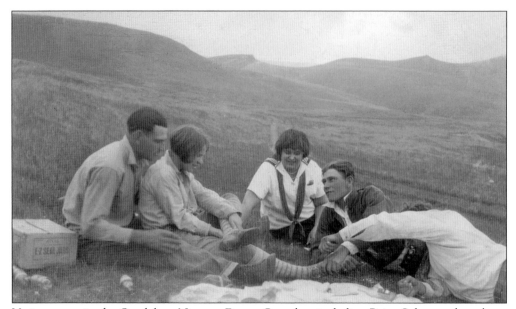

Various spots in the Guadalupe-Nipomo Dunes Complex, including Point Sal, served as places where members of younger generations could socialize with their peers without much adult supervision. Such opportunities did not come often in small-town Guadalupe. Here, Dorothy Bassi (center) socializes with her friends at Point Sal. (Family of Nadine Grisingher Ferini and Dario Ferini.)

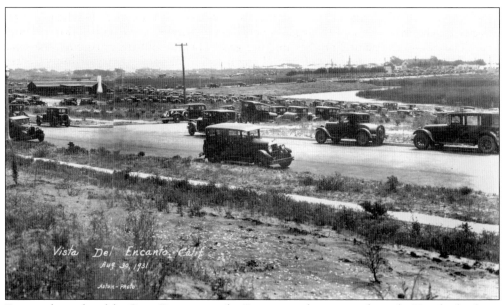

Even in the midst of the Great Depression, the Dunes complex attracted people. Hundreds of cars are parked at the Oceano Beach Auto Club on August 30, 1931. (*Santa Maria Times* files.)

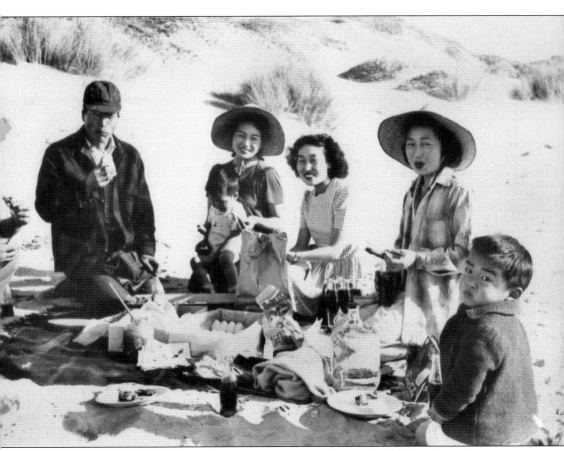

An Asian American family enjoys a picnic in the Dunes. The meal includes a classic American beverage—Coca Cola. This photograph includes what may be one of the earliest images of an invasive beach grass, which many used as a method of stabilizing sand to keep it from blowing away. The Southern Pacific Railroad used the grass when it built tracks through the sand dunes. The grass quickly grew out of control and is still being battled today. (History Center of SLO County.)

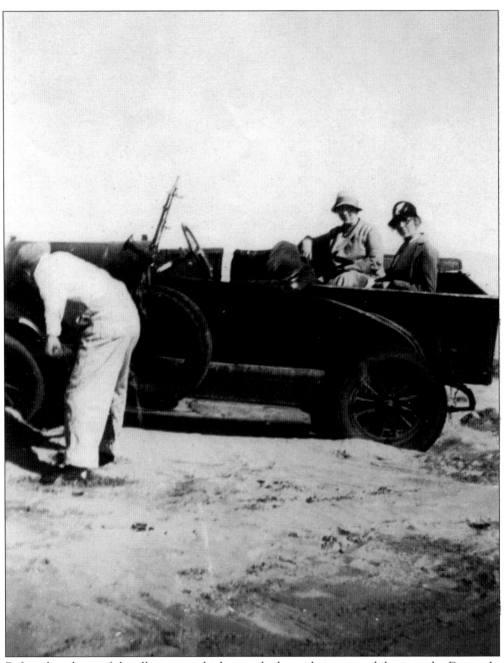

Before the advent of the all-terrain vehicle, people drove their automobiles into the Dunes. In many cases, the vehicles were old, beat-up cars that people were no longer using day-to-day. These visitors to the Dunes found themselves stuck in the dense sand in 1934. (Rancho de Guadalupe Historical Society.)

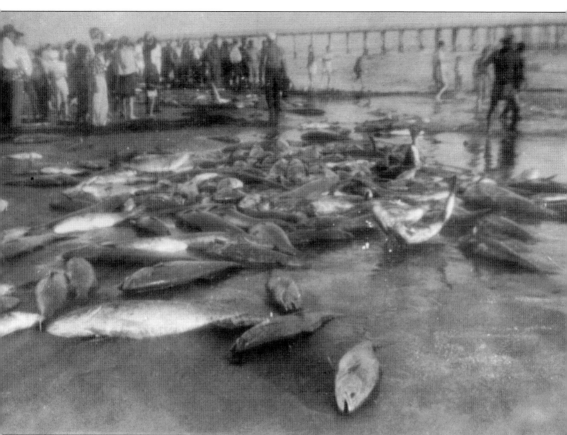

A large catch of sea bass lays on the shore of Pismo Beach in this undated postcard. The spectacle attracted a large crowd. The 1930s represented the period in which the largest numbers of sea bass were caught; their population has been in decline since. (History Center of SLO County.)

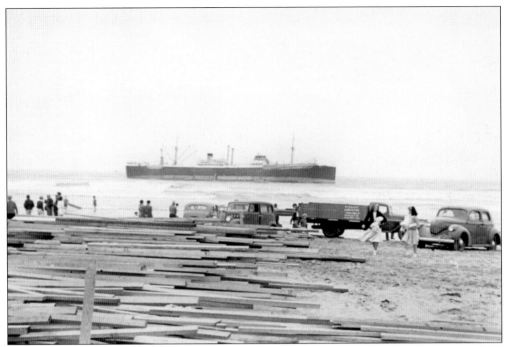

In September 1938, the Norwegian freighter *Elg* wrecked six miles south of Pismo Beach in the Dunes. The *Elg*'s captain decided to lighten the ship's load in an effort to re-float the ship, tossing its cargo of precious lumber overboard. Days of scavenging by locals feeling the pressure of the Great Depression caused chaos. Scavengers held no legal right to the wood they collected, and often had their collected wood stolen while they were away collecting more. Several people drowned while scavenging the lumber. (History Center of SLO County.)

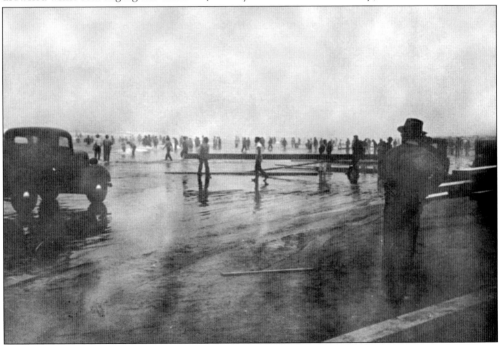

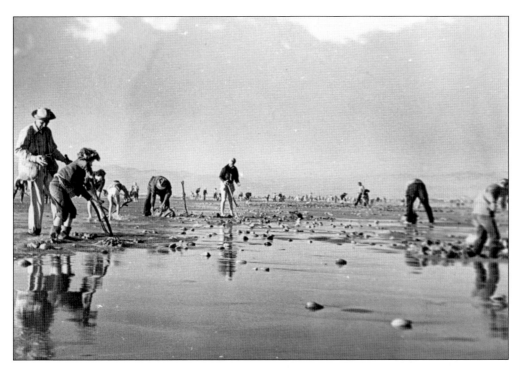

The Pismo clam calls many beaches around California home, but the largest have been collected on the Central Coast. People have been using the clams as food for thousands of years, as indicated by their prevalence in indigenous middens. In the early 1900s, teams of horses pulling plows were used to collect clams, which were subsequently fed to hogs and chickens. Commercial diggers collected an estimated 6.25 million pounds between 1916 and 1947. During the Great Depression, painted clam shells were utilized as currency. Commercial digging was banned in 1948, and the daily catch limit has been lowered from 200 a day since 1911. (History Center of SLO County.)

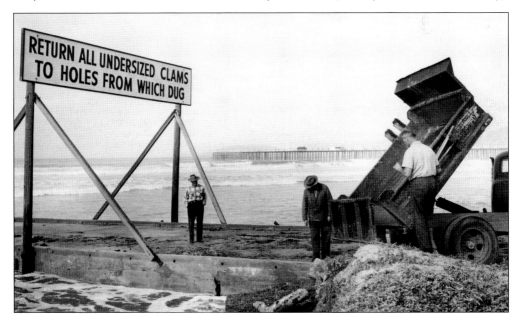

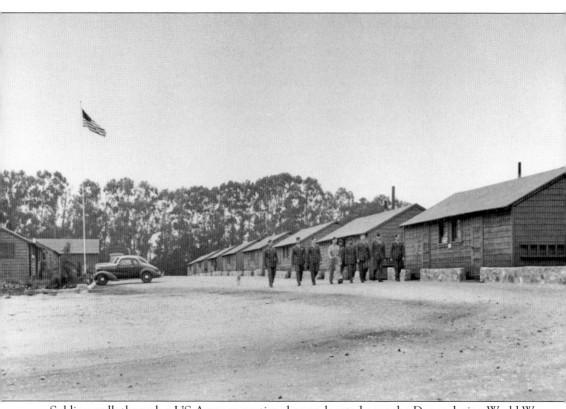

Soldiers walk through a US Army recreational camp located near the Dunes during World War II. The camp served as a facility for soldiers on leave who were stationed in California. (History Center of SLO County.)

Five

HOLLYWOOD COMES TO TOWN

"The greatest art in the world is the art of storytelling," said Cecil B. DeMille. He was one of several movie executives who experienced the unique landscape that the Guadalupe-Nipomo Dunes and the City of Guadalupe could provide as a movie backdrop. Few regions have lent their landscape to movies as often as Guadalupe and the Dunes. The region has co-starred in films by representing other regions, including Africa, deserted Caribbean islands, and small fictional towns.

A significant milestone in the local production of films was the making of *The Sheik* in 1921. The Famous Players–Lasky Corporation produced the movie and set a precedent for film production in the Guadalupe-Nipomo Dunes. Thanks to *The Sheik,* Famous Players–Lasky was already familiar with the Guadalupe-Nipomo Dunes when Cecil B. DeMille decided to create an epic film, *The Ten Commandments,* two years later. More recent productions to follow in the path of these early films include *Pirates of the Caribbean: At World's End* and *GI Jane.*

When films are locally shot, famous actors and actresses are introduced to the area. The likes of Rudolph Valentino, Clark Gable, Joan Crawford, Gary Cooper, Marlene Dietrich, and even Johnny Depp and Demi Moore have made cameos in Guadalupe. Actors and extras have left their mark on the town. Perhaps most famously, DeMille left the entire movie set from *The Ten Commandments* in the Dunes, along with thousands of items that nearly 5,000 actors, extras, and construction workers used on the set. The Dunes Center houses everything from gargantuan statuary to makeup compacts and "cough syrup" bottles from Prohibition that were utilized during the making of the movie.

Motion pictures have played a flamboyant part in local legend, but they are also historically significant. Past movies provide an insight into the development of technology. They give people an idea of the type of person society found attractive at the time of production. Perhaps most important, movies provide insight into the issues that a society is coping with at a given time. Locally produced films have dealt with everything from miscegenation and morality issues in the 1920s, to more recent issues such as changing gender roles.

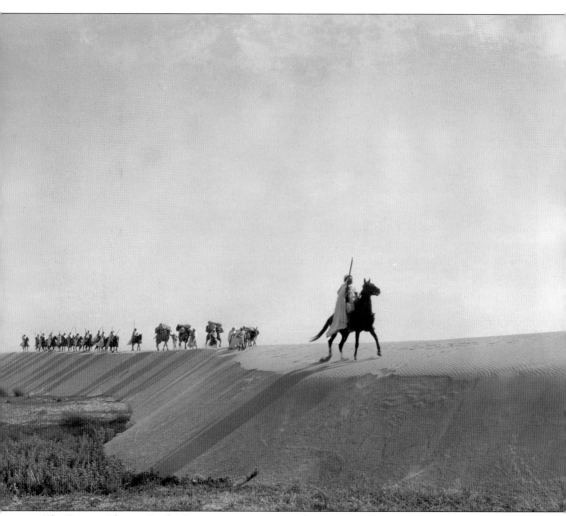

The Famous Players–Lasky Corporation was created as a merger between the Famous Players Film Company and the Feature Play Company in 1916. The motion picture and distribution company may have been the first to use the Guadalupe-Nipomo Dunes as a scenic backdrop in the silent film industry. *The Sheik*, produced in 1921 and starring Rudolph Valentino and Agnes Ayers, made both the Guadalupe-Nipomo Dunes and the Famous Players–Lasky Corporation well known. (Margaret Herrick Library Collection, Academy of Motion Picture Arts and Sciences.)

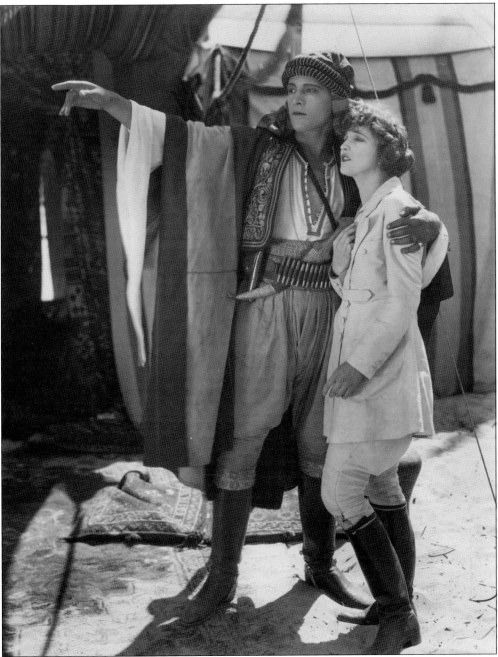

Directed by George Melford, *The Sheik* was a romantic film that propelled 1920s heartthrob Rudolph Valentino to fame. Actress Agnes Ayers played a strong-willed woman who chose to vacation in the Middle East. She was kidnapped and subsequently fell in love with her captor, a sheik played by Valentino. The movie, an adaptation of a novel written by Edith Maude Hull, caused controversy when it failed to address miscegenation and other topics that were part of the novel. (Margaret Herrick Library Collection, Academy of Motion Picture Arts and Sciences.)

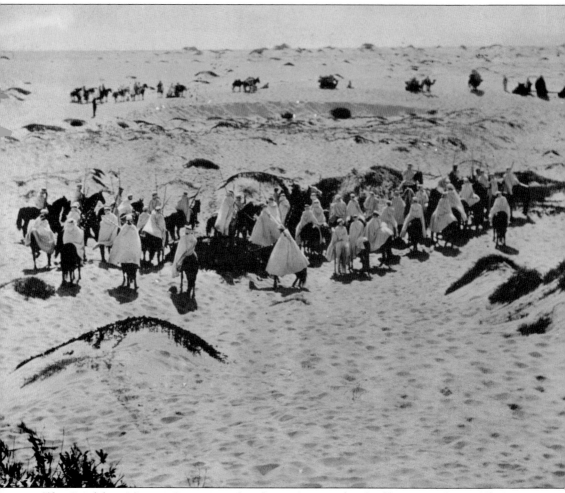

The Guadalupe-Nipomo Dunes served as the perfect stand-in for films set in the Middle East or North Africa. The region is relatively close to Hollywood, and the climate is more comfortable to work in than many Southern California deserts. Images such as this demonstrate the types of vegetation that have lived in the Dunes at different points in time. Native plants, possibly sand verbena, cover the hills in the sand dunes while extras prepare for filming. Riders on camels are in the distance. (Margaret Herrick Library Collection, Academy of Motion Picture Arts and Sciences.)

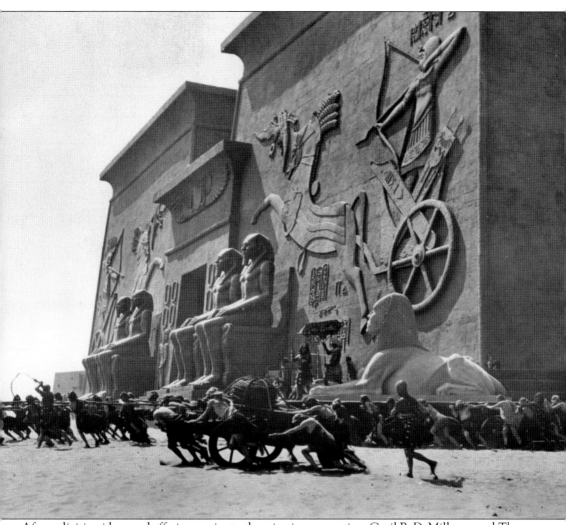

After soliciting ideas and offering a prize to the winning suggestion, Cecil B. DeMille created *The Ten Commandments* in 1923. Like *The Sheik,* the movie was produced by the Famous Players–Lasky Corporation and filmed in the Guadalupe-Nipomo Dunes. Due to the lack of special-effects technology, DeMille had Paul Iribe, who heavily influenced the Art Deco movement, design a 120-foot-tall by 720-foot-wide backdrop. (Dunes Center files.)

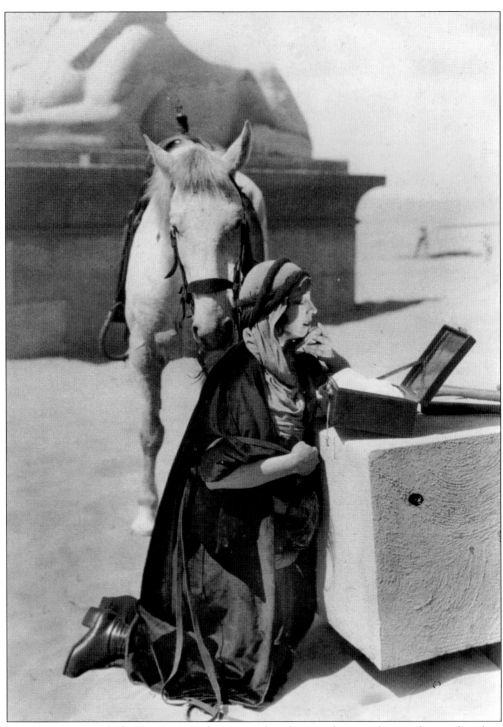

The 1923 version of *The Ten Commandments* employed a cast that was famous during the silent film era. Among the stars was Estelle Taylor, shown here putting on makeup for her role as Miriam, Moses' sister. Taylor has a star on the Hollywood Walk of Fame for her contribution to the motion picture industry. (Dunes Center files.)

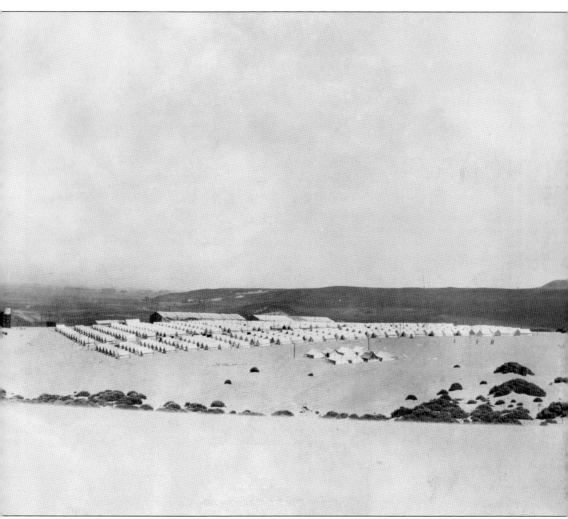

To complete the task of filming *The Ten Commandments* in May and June 1923, DeMille reportedly required 3,500 actors and extras, in addition to 1,500 workers to build the set. The massive numbers of workers required a living area, dubbed "Camp DeMille." A military unit traveled from Monterey to build the World War I–style encampment. Many artifacts remain from the camp and are on display at the Dunes Center, including Prohibition-era "cough syrup" bottles. The concoction contained high percentages of alcohol. (Dunes Center files.)

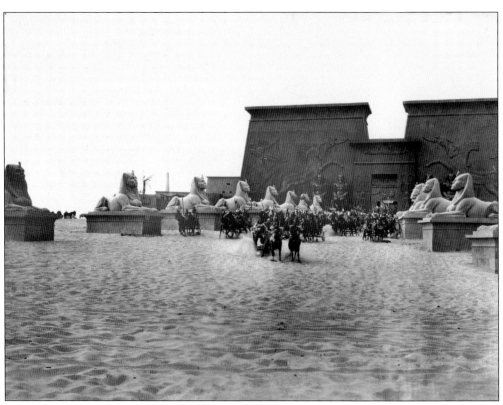

Perhaps the most famous of the props from *The Ten Commandments* are the 21 sphinxes that lined a road leading to the massive movie set. DeMille hired Edward Curtis to manage the film's photography. Curtis, known for his presidential photography and many ethnographic images of the last traditional Native Americans, may have produced the above photograph. Below is an image of the "Avenue of the Sphinxes" captured by a local amateur photographer. (Above, Dunes Center files; below, Ernest De Gasparis.)

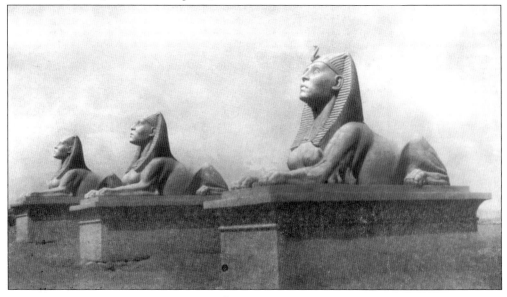

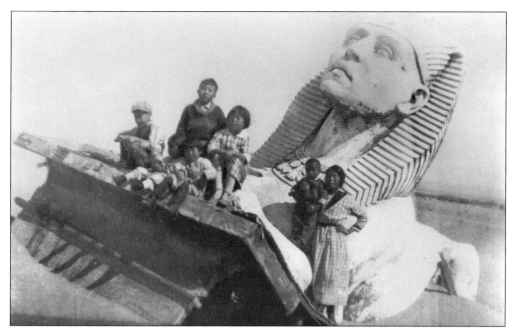

Throughout the years, many people posed for photographs with the sphinxes. Some created portraits upon coming across the surprisingly random sphinxes sticking out from the Dunes. Others took photographs when the sphinxes were moved to places such as the Santa Maria Country Club or the Morganti Ranch. Above, a Japanese family poses with one of the sphinxes left behind in the dunes. In the image to the right, Gloria (left) and Madelyn Brebes pose at the Egyptian-inspired sphinx with the Shimizu boys, whom they babysat. (Above, History Center of SLO County; right, Frank and Yolanda Soares.)

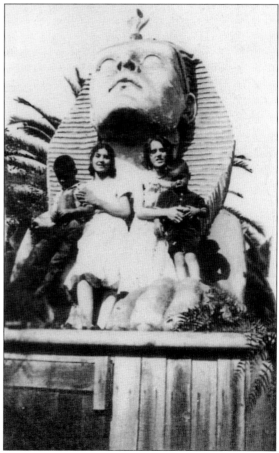

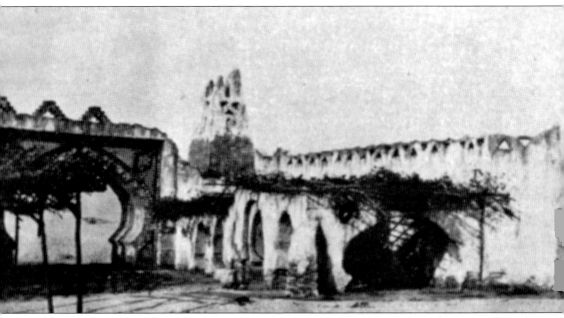

Morocco, starring Marlene Dietrich and Gary Cooper, was filmed in the local dunes complex. The movie was set in the Northern African nation of Morocco. The arch on the left can be seen in the final moments of the film, when Dietrich's character abandons her life for her love. (Rancho de Guadalupe Historical Society.)

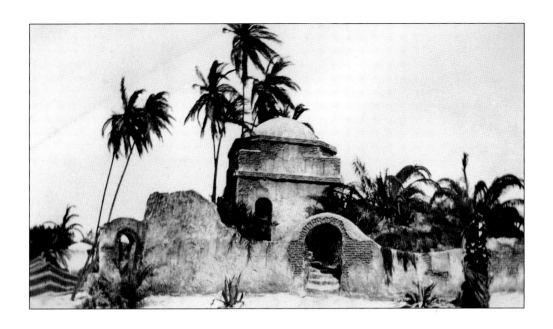

These photographs, captioned "In the heart of the Sahara. Another scene from the movie camp," capture another movie set left in the Dunes. The set was built for *She's a Sheik*, the third film in the series begun in 1921. Jesse Lasky produced the film, which Paramount Pictures distributed in 1927. The set was utilized again for *Beau Sabreur*, which debuted the following year. (Family of Nadine Grisingher Ferini and Dario Ferini.)

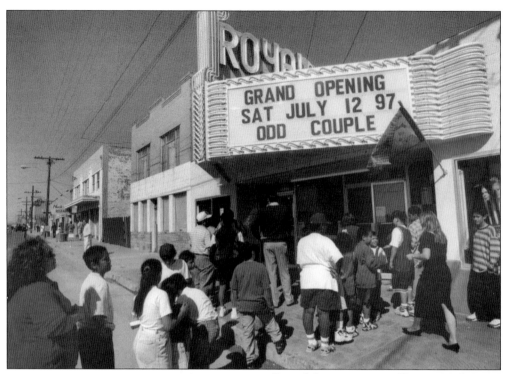

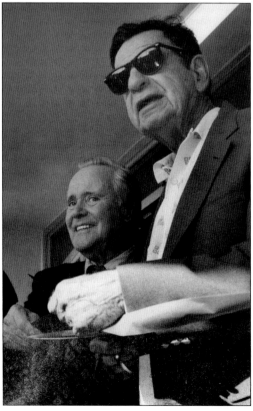

One of the more recent films created in Guadalupe is *The Odd Couple II*, starring Jack Lemmon and Walter Matthau. Filmmakers transformed a Guadalupe hotel once known as the Central Hotel into the Santa Florita Hotel. The owners decided to keep the new name in honor of the movie. The film debuted at Guadalupe's Royal Theater on July 12, 1997. At left, the film's stars, Lemmon (left) and Matthau, attend the premiere. (Rancho de Guadalupe Historical Society.)

Six

CONTINUITY AND CHANGE IN GUADALUPE AND THE DUNES

In a retrospective moment while writing his autobiography, Cecil B. DeMille analyzed the potential results of his past actions on the future. "If 1,000 years from now, archaeologists happen to dig beneath the sands of Guadalupe, I hope that they will not rush into print with the amazing news that Egyptian civilization, far from being confined to the Valley of the Nile, extended all the way to the Pacific Coast of North America. The Sphinxes they will find were buried there when we . . . dismantled our huge set of . . . the Pharaoh's city." Fast-forward several decades, and documentary filmmaker Peter Brosnan was driven to unearth the massive movie set that made the Dunes near Guadalupe one of the most unique historical sites on Earth.

The postwar era represents a time when everything was built on the foundation established by those who came before, albeit sometimes not for the original intentions. Artifacts from *The Ten Commandments* stir excitement among locals and tourists. The pieces also serve as a reminder of art and archaeology; originally they were objects meant to serve a purpose as a film backdrop for two months in 1923, but today they represent an era of excitement and innovation. *The Ten Commandments* artifacts definitely represent art that has outlasted its original intention.

Today, large spans of the Guadalupe-Nipomo Dunes Complex are open for public enjoyment, thanks to the actions of those who have come before. During the 1960s, environmentalist Kathleen Goddard Jones teamed with off-road vehicle users to keep parks open to the public, demonstrating that great things can happen when people work for a common goal.

Many buildings that Guadalupe's forebears constructed are still standing and have been converted to uses outside of their original intention. City Hall was once an elementary school. Old shops have been converted to modern day restaurants. Festivals celebrate cultures from distant places, from which Guadalupe residents' ancestors immigrated. It is this continuity with the past, along with enough flexibility to change, that keeps the traditions of Guadalupe and the Dunes alive today.

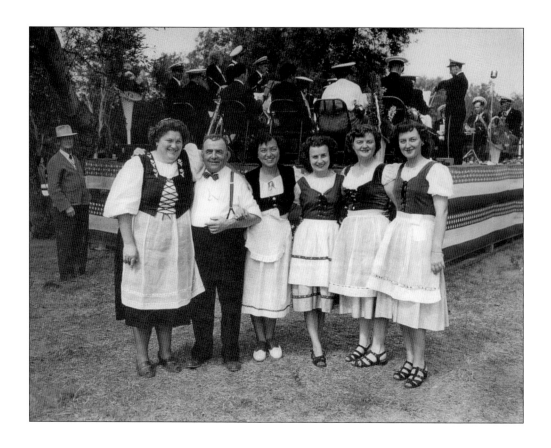

Descendents of the Swiss-Italian immigrants who settled in the Guadalupe area once held festive gatherings to celebrate their heritage. In the above photograph are, from left to right, Romelda Biaggini, Mario Carenini, Mary Tognazzini, Sandra Spazzadeschi, Alma Dalla Costa, and Olivia Dalla Costa. The below photograph captures the festive scene at LeRoy Park in Guadalupe in 1947. (Courtesy of the Rancho de Guadalupe Historical Society.)

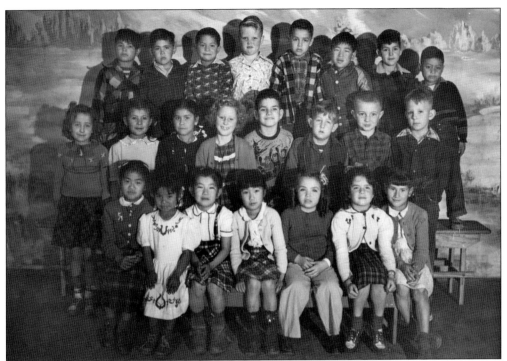

In a tradition that seems to span generations, a class photograph captures Guadalupe elementary school students in 1947 or 1948. (Family of Nadine Grisingher Ferini and Dario Ferini.)

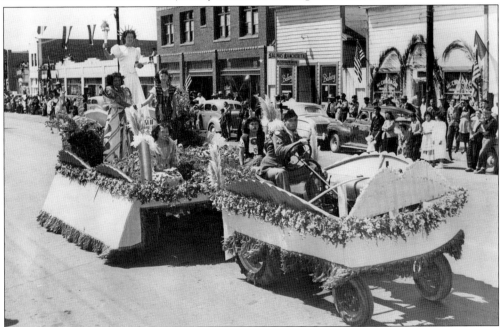

The Filipino Community Float drives down Guadalupe's main street in 1949. Portraying the Statue of Liberty is Livian Nelson Maniaci. In the front row are Ampara Amido Okamoto (left) and Vickie Garcia Reyes Canas. The driver is Silvio Bondietti. In the back row sit Petrona Imperio Amido (left) and Cecilia Martinez. (Rancho de Guadalupe Historical Society.)

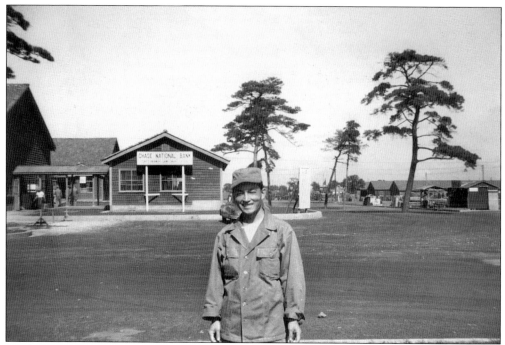

Hugh Maenaga poses at Camp Drake in Japan, which served as a joint US Army and Air Force base. Like Maenaga, Guadalupe's residents have continually answered the nation's call for service. (Hugh Maenaga.)

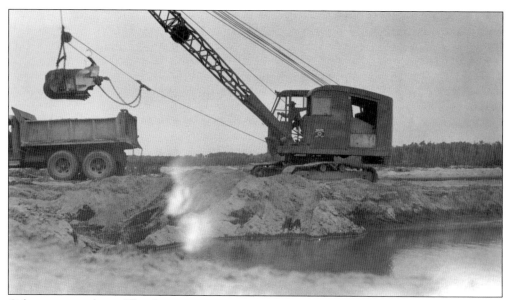

Caltrans was in the middle of a massive construction project on August 6, 1952, possibly the Santa Maria River Bridge. The caption of this photograph reads, "IBM Pit at S.M. River." (Caltrans.)

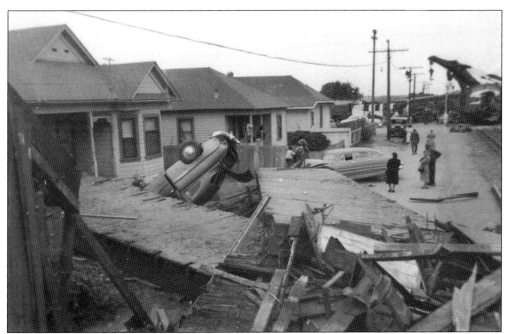

On October 22, 1952, an accident occurred on the Southern Pacific Railroad. While driving through Guadalupe, 10 cars from two freight trains and their engines derailed. A large fire followed that destroyed one of the engines and a house. The accident injured seven people and stopped all train traffic between Los Angeles and San Francisco. According to the *Santa Maria Times*, a steam engine was switching rails when the left corner of an oncoming train sideswiped it, causing it to jump the rails and swing over on its side. The other train jackknifed, burst into flames, and set the nearby building on fire. That seems to have been a troublesome year for Southern Pacific, which also had a train marooned at Donner Pass. In addition, an earthquake that struck nearby Kern County closed portions of the company's track. (Jim Mills.)

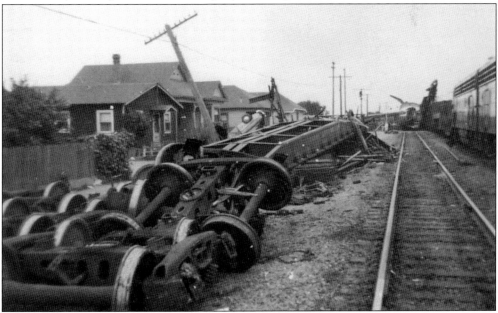

In 1953, Caltrans took this photograph of the Southern Pacific Railroad bridge, looking south into Guadalupe. In the distance is Guadalupe's iconic water tower, which was constructed in 1928. It was declared structurally unsafe after the 2003 San Simeon earthquake. A new tank, built in 2008 to replace the aging structure, proclaims Guadalupe as "The Gateway to the Dunes" and has a light on top that serves as a warning for aircraft. (Caltrans.)

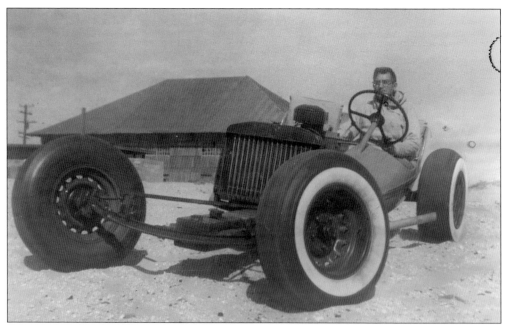

In 1954, Arnold Teague posed in this dune buggy. In the post–World War II era, recreationists realized they could strip down cars and modify them to be more suitable for driving in the Dunes. For some, the vehicle of choice was the VW bug, due to its size. Other drivers utilized different types of vehicles or created their own altogether unique ones. (History Center of SLO County.)

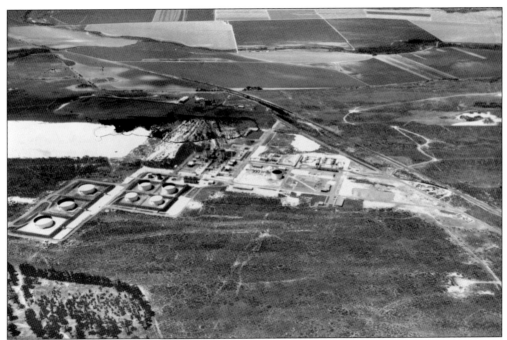

During the 1940s, exploration resulted in the discovery of oil in the Guadalupe-Nipomo Dunes Complex. As a result, the area was zoned for industrial use, and an oil refinery was built. Pictured here is the Union Oil Cokemy Plant, now known as Phillips 66's Santa Maria refinery. (History Center of SLO County.)

Tensions among dune users and private property owners arose in the 1950s and 1960s. Off-highway vehicle drivers wanted to utilize the Dunes for recreation, and nature lovers wanted to see the Dunes saved for the public. Private interests purchased large parcels of land and erected signs such as this one. (History Center of SLO County.)

A sign once posted near what is now Rancho Guadalupe Beach warns visitors to take heed for a variety of reasons, including the presence of private property and dangerous conditions. Perhaps most appropriate for the time is the notification to visitors that they are in a missile fallout area, due to the proximity to Vandenberg Air Force Base. (Dunes Center files.)

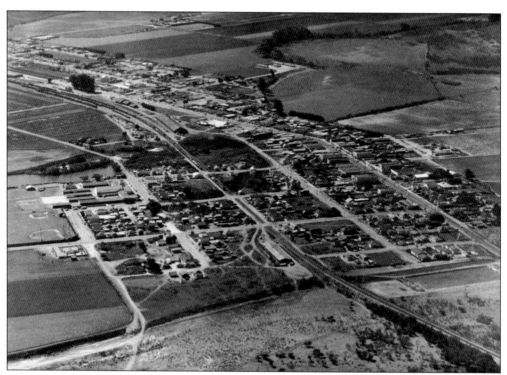

This aerial photograph captures the entirety of Guadalupe in 1955. The Rancho de Guadalupe adobes were still standing, along with much of the other historical architecture found in the city. The region was on the verge of expansion, with many new subdivisions to come. (Ernest De Gasparis.)

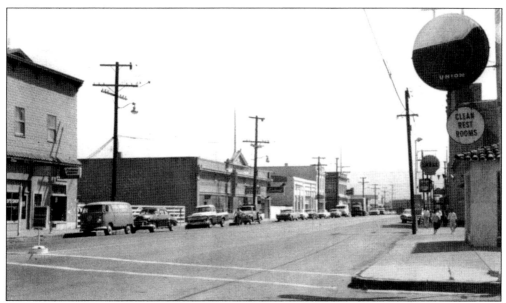

This mid-20th-century image captures downtown Guadalupe. The Commercial Hotel is on the left, and a service station is located across the street. Several decades after this photograph was taken, on November 7, 1990, the service station exploded when an employee lit his torch to repair a lantern, causing vapor in the lantern to ignite. The explosion killed both the welder and his assistant, and many buildings in Guadalupe suffered damage. (Family of Nadine Grisingher Ferini and Dario Ferini.)

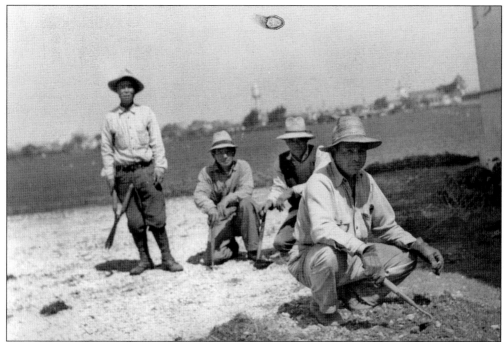

From the town's beginning to the present, agriculture continues to be an integral part of Guadalupe. This photograph was taken just south of Guadalupe. The city's water tower and city hall are visible in the background. (Rancho de Guadalupe Historical Society.)

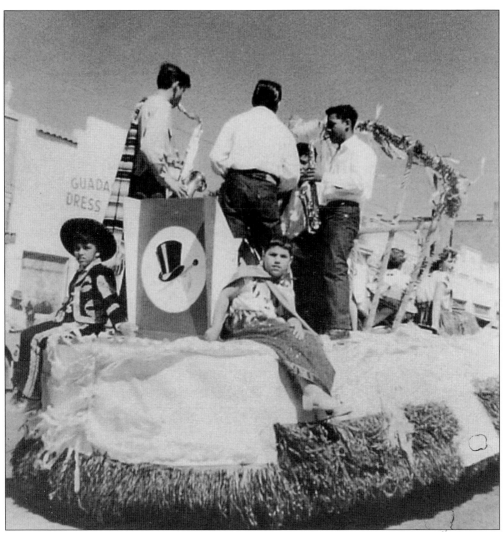

One of the many cultural events that have taken place in Guadalupe is the 16th of September Parade, which celebrates Mexican independence. This image captures fun times in 1955. Johnny Perry, at left on the tenor sax, performs with a band on a float built on a 1928 Chevy pickup. Perry later became the youngest person to serve on the city council, and was the proud owner of the famed Napa Auto Parts store and local history museum. Augie Lasada is on the saxophone, at right. (Rancho de Guadalupe Historical Society.)

As cars became ingrained in the American lifestyle during the postwar era, tourists from distant places were able to travel to the Dunes more easily and frequently for weekend getaways. Above, vehicles line the entire Dunes coastline from the Oceano area south. Below, a clammer shows off her bounty. (History Center of SLO County.)

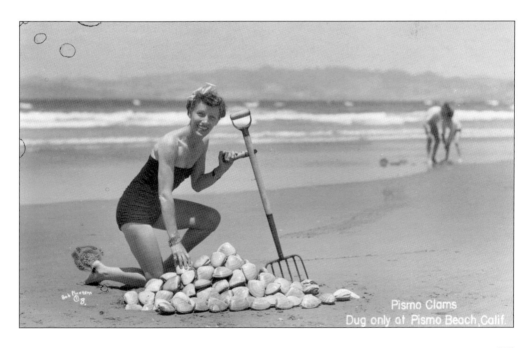

One of the unique stories from the Guadalupe-Nipomo Dunes Center is that of Kathleen Goddard Jones. Born in Santa Barbara, Jones became locally known when she advocated for the preservation of the dunes complex while PG&E explored the possibility of building a nuclear power plant in the area in the 1960s. Through dedication, many hours of research, and coordination with off-road vehicle groups, Jones proved that the Guadalupe-Nipomo Dunes Complex is a unique geographic feature containing many ecologically sensitive plants and animals and that the area should be open for public recreation. Jones is pictured here on the boardwalk that passes through Oso Flaco Lake. (Dunes Center files.)

In the early 1990s, a movement began to restore the Oso Flaco Lake area near Guadalupe. Thanks to funding from the California Coastal Conservancy, volunteers constructed the boardwalk that leads to the beach, including the bridge that spans the lake and allows for superb birding. California State Parks restored native vegetation in the region, allowing visitors to appreciate the local natural heritage. (Dunes Center files.)

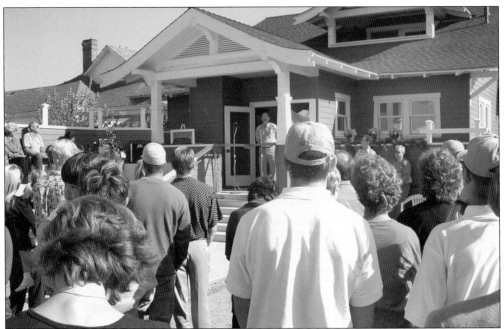

On December 3, 2000, a crowd gathered for a ribbon-cutting ceremony marking the opening of the restored Craftsman home that acted as the headquarters for the Dunes Center for 11 years. Wildlife officials and politicians, such as Lois Capps, spoke at the event, which marked a major milestone for the City of Guadalupe and the Dunes Center. (Dunes Center files.)

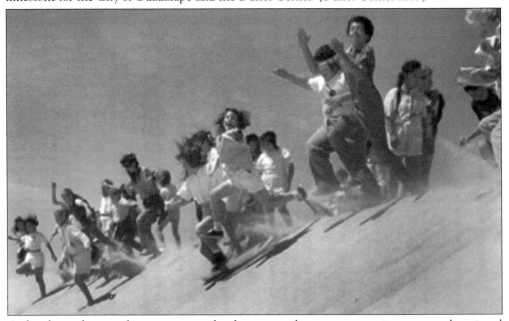

As has been the case for many years, the dunes complex serves as an important educational and recreational element for the local community. Every year, thousands of elementary school students have the opportunity to learn about nature and the world around them by exploring the Dunes. Pictured here are children "dune diving," or running and sliding down a sand dune. (Dunes Center files.)

Southern California PBS television personality Huell Howser enjoyed the unique Guadalupe-Nipomo Dunes. He featured the dunes complex and the City of Guadalupe in several of his television shows, and served as the lead on the Dunes Center's capital campaign early in the organization's history. Howser visited the Dunes Center and the property Chevron is currently working to restore in 2005. To the right, Howser (center) speaks with an unidentified woman and Gonzalo Garcia from Chevron. Below, he visits with local youth. (Dunes Center files.)

In the autumn of 2012, the Guadalupe Cultural Arts and Education Center (GCAEC) traded properties with the Dunes Center. The trade enabled the Dunes Center to consolidate properties while simultaneously allowing the GCAEC to expand. Many community members attended an event celebrating the transaction. Pictured above from left to right are Frances Romero, interim Dunes Center executive director; Karen Evangelista, GCAEC executive director; and Congresswoman Lois Capps. Among the community members attending the grand re-opening event was three-year-old Matthew Moulder, pictured at left, who participated in the Dunite legacy by busily coloring his own *Dune Forum* cover. The publication was conceived by the bohemian group that called the dunes home in the 1930s and 1940s. (Dunes Center files.)

After the passing of Huell Howser in January 2013, the Dunes Center organized the Huell Howser Memorial Nature Hike at Oso Flaco Lake. The event honors the man who helped promote heritage sites around California, including the Guadalupe-Nipomo Dunes. The walk was the most well-attended Dunes hike on record and had to be broken up into smaller groups. Above, Dunes Center employee Lindsey Whitaker leads one group on the hike. To the right, a young nature lover walks through the Oso Flaco Lake riparian area. (Dunes Center files.)

After decades of dedication, documentarian Peter Brosnan oversaw the excavation of the face of a sphinx used in Cecil B. DeMille's 1923 *The Ten Commandments*. It was the second excavation, the first having taken place in the 1990s with the help of archaeologist John Parker. In early October 2012, archaeologists from Applied Earthworks excavated one of the 21 sphinxes. It was subsequently transported to Burbank, where restoration expert Amy Higgins reconstructed the face using plaster of paris, the same material used in the original construction of the set. (Dunes Center files.)

In May 2013, DeMille's sphinx head arrived at its new home at the Dunes Center. To the right, from left to right, volunteer Jim Reid, executive director Doug Jenzen, volunteer Gary Patterson, and restoration guru Amy Higgins (partially obscured) ponder the best way to move the object onto its new base, located up a stairway inside the Dunes Center. Below, Amy Higgins puts the final touches on the sphinx head prior to placing it in its permanent case. The operation was kept a secret, in order to promote suspense among the public as to what object from the movie set was going to be unveiled. (Nancy Jenzen.)

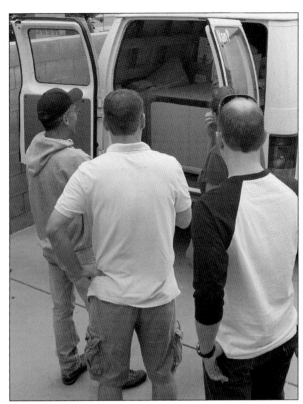

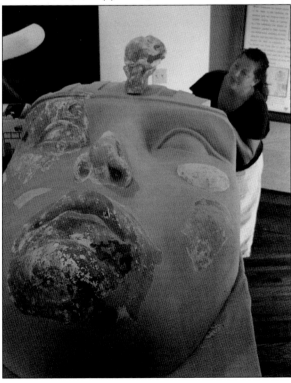

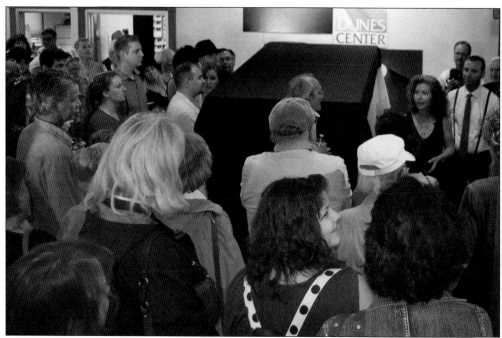

The large crowd that gathered in the Dunes Center in June 2013 let out an audible gasp as board president Frances Romero, executive director Doug Jenzen, and documentary filmmaker Peter Brosnan pulled the cover to unveil the sphinx head. The unveiling took place during a 1920s-themed event that coincided with the 90th anniversary of the filming of *The Ten Commandments*. The event was attended by Cecil B. DeMille's granddaughter, Cecilia DeMille Presley. Above, Frances Romero (right) speaks to the crowd about the Dunes Center. Below, Peter Brosnan (center right) speaks to the crowd about the significance of the archaeological project. (Dunes Center files.)

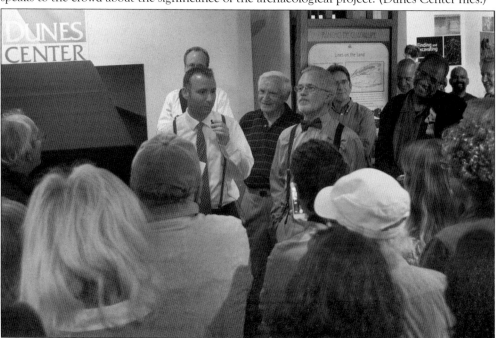

Dunes Center executive director Doug Jenzen and board of directors president Frances Romero are pictured at the unveiling ceremony. The 1920s-themed event featured music, clothing, and beverages inspired by the Roaring Twenties, when Cecil B. DeMille filmed *The Ten Commandments*. (Dunes Center files.)

In August 2013, the silver screen was in vogue again as the San Luis Obispo International Film Festival (SLOIFF) held a screening of DeMille's 1923 *The Ten Commandments*. The crowd gathered in Guadalupe's City Hall auditorium, which served as a theater when the building was an elementary school, built in 1929. The event was part of SLOIFF's celebration of locally filmed movies, SLO County on the Silver Screen. (Dunes Center files.)

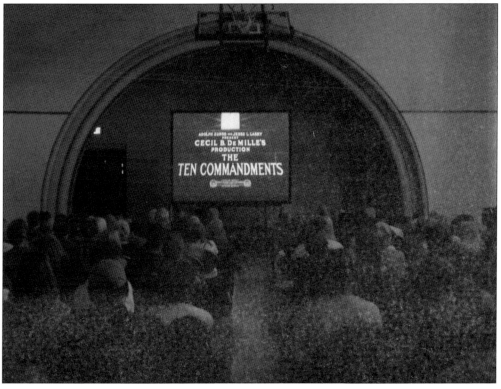

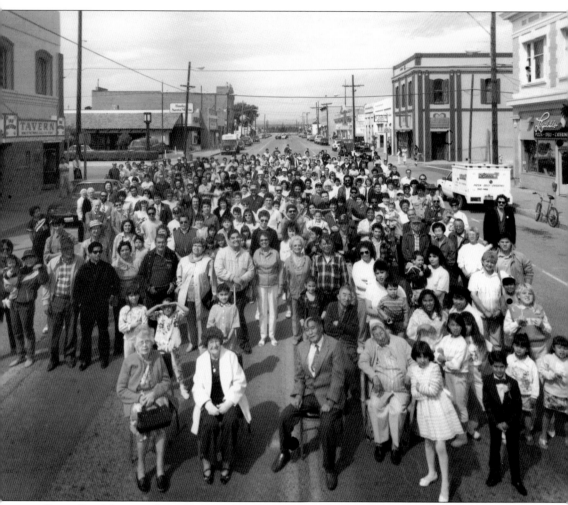

Every Guadalupe resident was invited to participate in the Guadalupe Mural Project's attempt to photograph every member of the city together downtown on Saturday, April 29, 1989. Residents young and old posed on Guadalupe Street/Highway 1, demonstrating that one can see the world when they look into the faces of Guadalupe's citizens. (Dunes Center files.)

BIBLIOGRAPHY

Bancroft, Hubert Howe. *The Works of Hubert Howe Bancroft, Volume 20.* San Francisco: A.L. Bancroft and Company, 1882.

Brosnan, Peter. *Co-Starring the Guadalupe Dunes: 85 Years of Hollywood Movies in the Guadalupe Dunes.* Self-published, 2006.

Contreras, Shirley. *The Good Years: Snippets of Santa Maria Valley History.* Santa Maria, CA: Santa Maria Valley Historical Society, 2001.

Cornell, Virginia. *Defender of the Dunes: The Kathleen Goddard Jones Story.* Carpenteria, CA: Manifest Publications, 2001.

Fagan, Brian. *Snap Shops of the Past.* Walnut Creek, CA: Altamira Press, 1995.

Hammond, Norm. *The Dunites.* Arroyo Grande, CA: South County Historical Society, 1992.

Hoffman, Naomi Cummings. *Colorful Guadalupe: A History of Guadalupe, California.* Self-published, 2002.

Mason, Jesse D. *History of Santa Barbara County, California, With Illustrations and Biographical Sketches of its Prominent Men and Pioneers.* Oakland, CA: Thompson and West, 1883.

Nelson, Bob. *Sagas from the Pages of* Central Coast, *the Magazine of Pleasures and Pursuits.* Santa Maria, CA: RJ Nelson Enterprises, 1994.

Phillips, Michael James. *History of Santa Barbara County, California from its Earliest Settlement to the Present Time.* Los Angeles: S.J. Clarke Publishing Company, 1927.

Signor, John R. *Southern Pacific's Coast Line.* Wilton, CA: Signature Press, 1994.

DISCOVER THOUSANDS OF LOCAL HISTORY BOOKS FEATURING MILLIONS OF VINTAGE IMAGES

Arcadia Publishing, the leading local history publisher in the United States, is committed to making history accessible and meaningful through publishing books that celebrate and preserve the heritage of America's people and places.

Find more books like this at
www.arcadiapublishing.com

Search for your hometown history, your old stomping grounds, and even your favorite sports team.

Consistent with our mission to preserve history on a local level, this book was printed in South Carolina on American-made paper and manufactured entirely in the United States. Products carrying the accredited Forest Stewardship Council (FSC) label are printed on 100 percent FSC-certified paper.

MADE IN THE